After Rabin: New Art from Israel

The Jewish Museum New York Under the auspices of The Jewish Theological Seminary of America

After Rabin

New Art from Israel

• Aya & Gal • Ido Bar-El
• Avner Ben-Gal
• Pinchas Cohen Gan • Nurit David
• Belu-Simion Fainaru
• Barry Frydlender
• Gideon Gechtman
• Moshe Gershuni • Pesi Girsch
• Israel Hershberg • Nir Hod
• Joel Kantor • Zvika Kantor
• Uri Katzenstein • Roi Kuper • Moshe Kupferman
• Raffi Lavie • Merilu Levin • Limbus Group • Ariane Littman-Cohen • Hilla Lulu Lin
• Tal Matzliah • Adi Nes • Lea Nikel • Moshe Ninio • Ibrahim Nubani • Gilad Ophir • David Reeb
• Simcha Shirman • Doron Solomons • Igael Tumarkin • Uri Tzaig • Micha Ullman • Pavel Wolberg

SUSAN TUMARKIN GOODMAN *With contributions by Adam Baruch, Yaron Ezrahi, Tali Tamir*

This catalogue has been published
in conjunction with the exhibition
After Rabin: New Art from Israel
presented at:

The Jewish Museum, New York
September 13, 1998 – January 3, 1999

Copyright © 1998 The Jewish Museum, New York,
under the auspices of The Jewish Theological Seminary of America

Distributed by The University of Washington Press
P.O. Box 50096, Seattle, Washington 98145

Library of Congress Cataloging-in-Publication Data
Goodman, Susan Tumarkin.
 After Rabin : new art from Israel / Susan Tumarkin Goodman;
with contributions by Adam Baruch, Yaron Ezrahi, and Tali Tamir.
 p. cm.
 Published in conjunction with an exhibition presented at
The Jewish Museum, New York, Sept. 13, 1998–Jan. 3, 1999.
 Includes bibliographical references.
 ISBN 0–87334–076–0 (pbk.)
 1. Art, Israeli—Exhibitions. 2. Art, Modern—20th century—
Israel—Exhibitions. I. Baruch, Adam. II. Ezrahi, Yaron.
III. Tamir, Tali. IV. Jewish Museum (New York, N.Y.)
V. Title.
 N7277.G66 1998
 709'.5694'07456948—dc21 98–14181
 CIP

Principal Staff for the Exhibition and Catalogue
Exhibition Curator: Susan Tumarkin Goodman
Exhibition Coordinator: Tracy L. Adler
Project Assistant: Juliana D. Kreinik
Associate Exhibition Designer: Dan Kershaw
Graphic Designer: Sue Koch
Catalogue Editor: Sheila Friedling
Catalogue Designer: Lorraine Ferguson

Cover image:
Micha Ullman, *Day, Havdalah,* and *Midnight*
from the *Containers* series (detail), 1993
Collection The Israel Museum, Jerusalem.
Gift of Rita and Arturo Schwarz, Milan
PLATE 23

Printed and bound in Singapore

Contents

The Artists

Boldface numbers indicate pages with plates; the other numbers refer to pages with information about each artist.

Donors to the Exhibition

After Rabin: New Art from Israel
is made possible through major gifts from
THE JUDY AND MICHAEL STEINHARDT FOUNDATION,
and MARCIA RIKLIS AND MESHULAM RIKLIS.

Additional support is provided by
THE ROBERT M. BEREN FOUNDATION, INC.
Transportation assistance is provided by
EL AL ISRAEL AIRLINES.

Lenders to the Exhibition

Aya & Gal, Jerusalem
Roni and Yael Braun, Givataim
Pinchas Cohen Gan, Tel Aviv
Arnie and Nechami Druck, New York
Belu-Simion Fainaru, Haifa
Barry Frydlender, Tel Aviv
Gideon Gechtman, Rishon Le Zion
Pesi Girsch, Tel Aviv
Nir Hod, Tel Aviv
Joel Kantor, Tel Aviv
Zvika Kantor, Tel Aviv
Uri Katzenstein, Tel Aviv
Jonathan Kolber and Charles R. Bronfman, Tel Aviv
Roi Kuper, Tel Aviv
Moshe Kupferman, Kibbutz Lochamei Hagetaot
Merilu Levin, Jerusalem
Limbus Group, Tel Aviv
Hilla Lulu Lin, Kfar Bilu
Ariane Littman-Cohen, Jerusalem
Tal Matzliah, Tel Aviv
Adi Nes, Tel Aviv
Lea Nikel, Moshav Kidron
Moshe Ninio, Tel Aviv
Gilad Ophir, Tel Aviv
Orly and Avishai Shachar, New York
Simcha Shirman, Tel Aviv
Doron Solomons, Ramat Gan
Igael Tumarkin, Jaffa
Uri Tzaig, Tel Aviv
Robert Yohay, Tel Aviv
Pavel Wolberg, Tel Aviv
Private collection, New York
Private collections, Tel Aviv

Chelouche Gallery, Tel Aviv
Dvir Gallery, Tel Aviv
Givon Art Gallery Ltd., Tel Aviv
Har-El Printers and Publishers, Jaffa
The Israel Museum, Jerusalem
LiebmanMagnan, New York
Noga Gallery of Contemporary Art, Tel Aviv
Rabin Memorial Peace Center, Tel Aviv

Foreword

JOAN ROSENBAUM

Helen Goldsmith Menschel Director
The Jewish Museum

Since The Jewish Museum collects and exhibits the work of Israeli artists, there was a great interest among staff and trustees in marking the 50th anniversary of the birth of the state. The prevailing question, one that was debated and considered for quite a long time, was how best to commemorate the occasion, knowing that there are mixed feelings about the idea of celebration. What, in the visual expression of Israeli culture—from archaeological material and early Zionist posters to contemporary conceptual installations—would do justice to this landmark year? Should our program be celebratory, analytical, polemic, nostalgic? Our conclusion, in effect, was to bring Israeli voices into the Museum by means of this exhibition and accompanying catalogue, as curated by the Museum's senior staff member Susan Goodman, who has had a long, abiding interest in Israeli art. *After Rabin: New Art from Israel* presents artists and writers who, on the basis of their experience of daily life in Israel, are reflecting and interpreting a profound change in the culture that is particularly evident since the death of Prime Minister Yitzhak Rabin in 1995.

The exhibition, motivated by the 50th anniversary, yet with an identity and perspective of its own, directly and indirectly reflects an American-Israeli dialogue. The American voice is represented not only by the curator, but also by the context of The Jewish Museum in New York, located in this "diaspora" culture, in a city with a large, diverse Jewish population among whom the subject of Israel resonates with mixed responses—from the most fervent Zionist supporters to those who question the legitimacy of the Jewish state. The Jewish Museum is an institution that deliberately attempts to celebrate this diversity of Jewish identity and viewpoints, capturing the multiple dimensions of Jewish life and its many historic and continuous debates—including those on the subject of Israel—within the Museum's permanent and changing exhibitions.

Susan Goodman has handled the complicated task of creating an anniversary exhibition with admirable patience and skill, integrating her highly informed familiarity with current Israeli art and the social and cultural commentary of writers, art critics, curators, and academics. The result is evident in her interesting selection of artists, in the valuable Introduction to this catalogue, and in the illuminating responses of the Israeli thinkers who address three questions posed by Susan Goodman about the social and cultural climate in Israel today, particularly as it affects its art and artists. Their thought-provoking texts provide an Israeli perspective into the national, social, existential, and aesthetic concerns of contemporary Israeli artists.

Many representatives of the Museum's "family," including trustees, Museum Council members, and advisors, were closely involved in the creation and realization of *After Rabin: New Art from Israel*. From the lengthy deliberations of the staff and board exhibition committees to the dedicated work that went into the design, funding, installation, and publicizing of the exhibition and creation of the catalogue, everyone who has been involved has shown tremendous imagination and commitment, and I am most grateful to them. The individual donors to the exhibition have been truly inspirational to the project, as each has voiced and demonstrated his or her love of Israeli culture and a dedication to the international exposure and appreciation of its visual arts. For their enthusiastic support of this exhibition, I am deeply grateful to Judy and Michael Steinhardt, and to Marcia Riklis and her father, Meshulam Riklis. Their interest in the project has been extremely gratifying, and their major gifts have helped make possible its realization. I am also very appreciative of Robert M. Beren for his support of the exhibition, and for the further generosity he has demonstrated toward the Museum's permanent collection. Additional thanks for financial support are due to EL AL Israel Airlines for its important assistance with transporting the works in the exhibition from Israel to the United States and back. Finally, I extend

great appreciation to the artists for their cooperation in exhibiting their work, and to all of the collectors, museums, galleries, and artists, listed on page 6, who graciously have been lenders to the exhibition.

After Rabin reflects a complex moment in Israel, revealing conflicts between the interior landscape of individual artists and the harsh political and social environment of Israeli life. Yet Israel is still in many ways a young state, in a process of development on many fronts, including its visual arts tradition. With the continued generosity of donors and interest of staff and trustees, The Jewish Museum can persist in nurturing the vitality of Israeli art and can look forward to new American-Israeli dialogues as well as new chapters in the lives and careers of Israeli artists—productive, provocative, and peaceful—"After Rabin."

Acknowledgments

SUSAN TUMARKIN GOODMAN

Over the years, The Jewish Museum's Israeli exhibitions have explored significant aesthetic moments in Israel's cultural history. Although this exhibition focuses on the most current forms of visual expression, it should be viewed within the larger context of the Israeli artistic landscape. Indeed, the exhibition includes a few artists whose work has been exhibited at The Jewish Museum in the past as well as emerging artists who show here for the first time.

During the course of organizing the exhibition, my colleagues and I examined many issues, most critically, how will our approach appear to viewers outside the Israeli cultural milieu? Do cultural codes evaporate when works are "read" by outsiders? Does the success of artists in integrating local realities and those of the world at large determine their standing in the international artistic community?

We sensed also that the current cultural climate in Israel should be appraised by those who have been instrumental in its development. We therefore invited contributions by participants in the Israeli art world who are in close touch with the cultural issues that bear on consideration of this art. Three basic questions were posed to figures in Israel who are actively involved in shaping cultural and aesthetic discourse: Adam Baruch, art critic and President of the Camera Obscura School of Art in Tel Aviv; and Tali Tamir, art critic and Director of the Kibbutz Gallery in Tel Aviv. Yaron Ezrahi, Professor of Political Science at the Hebrew University of Jerusalem, a senior fellow at the Israel Democracy Institute, and author of *Rubber Bullets* (1997), has responded to the topic with his own analysis of the social, political, and cultural context of contemporary art in Israel. Their catalogue texts are part of the dialogue that we thought important to initiate with a non-Israeli public. I express my deep appreciation to the authors for their engaging and insightful interpretations of the Israeli cultural milieu that have contributed to an enriched reading of the art.

An exhibition of this nature, with its numerous loans from Israel, must depend upon the assistance and support of many individuals. In order to become more familiar with the most recent currents in Israeli art, it was necessary to rely upon "insiders" who provided invaluable assistance by sharing their formidable knowledge of Israeli art. In particular, my thanks to Meira Geyra, Artistic Director of the America-Israel Cultural Foundation; Ellen Ginton, Curator of Israeli Art at the Tel Aviv Museum of Art; Yaffa Goldfinger, Director of the Helena Rubenstein Library at the Tel Aviv Museum of Art; Dahlia Levin, Director and Chief Curator of the Herzliya Museum of Art; independent curator Vered Maimon; Nissan Perez, Horace and Grace Goldsmith Curator of Photography at The Israel Museum, Jerusalem; Doron Polak of Projective, Tel Aviv, and The Artist's Museum, Israeli Center; artist Roee Rosen; Rona Sela, Curator of Photography at the Tel Aviv Museum of Art; Sarit Shapira, Curator of the David Orgler Department of Israel Art at The Israel Museum, Jerusalem; Ami Steinitz of the Contemporary Art gallery, Tel Aviv; Rafi Gamzou, Consul for Cultural Affairs in the United States, Consulate General of Israel; and Yigal Zalmona, Chief Curator-at-Large, Yulla and Jacques Lipchitz Chief Curator of the Arts at The Israel Museum, Jerusalem.

I am grateful also to the following individuals in Israel and the United States whose help was crucial in assembling the work for this exhibition and catalogue: independent curator Sergio Edelstein; Naomi Givon and Shmuel Givon of the Givon Art Gallery Ltd., Tel Aviv; Nechama Gottlib of the Noga Gallery of Contemporary Art, Tel Aviv; Monique L. Har-El of Har-El Printers and Publishers, Jaffa; Amalya Keshet, Head of Visual Resources at The Israel Museum, Jerusalem; Julie Maimon and Adi Shapira of the Julie M. Gallery, Tel Aviv; Dvir Intrator of the Dvir Gallery, Tel Aviv; Nira Itzhaki of the Chelouche Gallery, Tel Aviv; Elsa Longhauser, Director, Galleries at Moore

College of Art and Design, Philadelphia; Amitai Mendelsohn at The Israel Museum, Jerusalem; Renée Schreiber, Director of Cultural Events in the Department of Cultural Affairs, Consulate General of Israel; Judith Spitzer, Associate Curator of the David Orgler Department of Israel Art at The Israel Museum, Jerusalem; and Jack Tilton and Julie Braniecki of the Jack Tilton Gallery, New York.

To Revital Silverman, my special thanks for her masterful work in coordinating the loans from Israel.

An undertaking this complex could never have been realized without the support of the many people on The Jewish Museum staff who gave of their expertise and talents in organizing and coordinating this exhibition. I especially wish to thank Ruth Beesch, Deputy Director for Program. Even prior to her arrival at The Jewish Museum in the summer of 1997, she entered into a dialogue concerning the formulation of the exhibition. Her insights have continued to inform and guide each phase of the project.

The following colleagues at The Jewish Museum provided invaluable expertise and advice at various stages of the exhibition: Stacey Barson, Merchandise Buyer; Tslilit Ben-Nevat, Library Manager; Alessandro Cavadini, Audiovisual Coordinator; Robin Cramer, former Director of Product Development; Susan Davis, Director of Development, and Tara Tuomaala, former Assistant Director of Program Funding; Thomas Dougherty, Deputy Director for Administration; Josh Feinberg, Educator; Al Lazarte, Director of Operations; Lisa Malin, Coordinator of Adult Outreach Education; Susan L. Palamara, Registrar and Collections Manager, and Lisa Mansfield, Associate Registrar; Grace Z. Rapkin, Director of Marketing; Anne Scher, Director of Public Relations; Debbie Schwab, Director of Retail Operations; Deborah Siegel, Director of Membership and Annual Giving; Marjorie Weinstein, former Exhibition Assistant for Traveling Exhibitions; Aviva Weintraub, Director of Media and Public Programs; Alex Wittenberg, Marketing and Public Relations Coordinator; and Carole Zawatsky, Director of School, Family, and Outreach.

Sheila Friedling deserves special acknowledgment for editing this catalogue with skill and sensitivity. She offered invaluable advice and masterful editing during all phases of production of the manuscript. The Hebrew texts by Adam Baruch and Tali Tamir were effectively translated by Michal Dekel.

It has been very rewarding to work with Lorraine Ferguson, whose expertise and ingenuity have informed the catalogue design. Her rare commitment and creativity have had a major impact in shaping this book.

Stuart Silver, Consultant and Advisor, with the assistance of Daniel Kershaw, Associate Exhibition Designer, created an effective exhibition design, which thoughtfully integrates the works of art and related concepts. Sue Koch enhanced the installation with her creative graphic design, and Sara Schrager contributed an effective lighting design.

My gratitude to Tracy Adler, Exhibition Assistant, who helped to coordinate this exhibition from its outset with dedication and patience; and to Juliana Kreinik, Project Assistant, for her unstinting efforts on behalf of the catalogue and exhibition. Special thanks to my colleagues Heidi Zuckerman Jacobson, Assistant Curator, and Norman Kleeblatt, Susan and Elihu Rose Curator of Fine Arts, for their support, advice, and encouragement during the years of planning for the current exhibition.

We are very grateful to the artists for the opportunity to include their work, not seen before in this country.

Finally, I wish to express my sincere gratitude to Joan Rosenbaum, The Jewish Museum's Director, for her vision and guidance in determining the most effective means to communicate the artistic climate in Israel today. Without her initial inspiration, conceptual input, and continuing support, this project could not have been realized.

After Rabin: New Art from Israel

After Rabin: An Introduction

SUSAN TUMARKIN GOODMAN

I recently gave a lecture on contemporary Israeli art at a synagogue in New York City. My presentation, which explored current artistic developments in Israel as well as preeminent contemporary Israeli artists, was met with almost unanimous discomfort and unease. The audience raised questions about the loss of aesthetic values and authenticity, about the art becoming arid and devoid of spirituality, and too focused on discord and pain.

I offer this anecdote to illustrate the difficulty for many Americans of accepting the harsh, unadorned, often subversive work of current artists in Israel today. It also indicates the extent to which Israel is subject to American expectations, and how difficult it for a museum in New York to address the reality of contemporary Israeli culture free of preconceptions, myth, or cliché. American Jews confronted with new Israeli art are forced to acknowledge that the country in which they have invested hopes and dreams, and which many still regard as the ultimate Jewish haven, can no longer be perceived in monolithic or utopian terms. In fact, the history of art in Israel is a complex one, determined by numerous factors relating to language, culture, religion, and politics. Contemporary Israeli art is neither circumscribed by a national ideology nor by a prevailing concept or uniform aesthetic vision.

We focus in this exhibition and catalogue on new art created during the three years since the assassination of Prime Minister Yitzhak Rabin in 1995, presenting the work of both established and emerging artists working in Israel today. They have all lived outside the country, many for extended periods. Although the artists are highly visible at home, and a number have been recognized internationally, the majority will be unknown here. The careers of these diverse artistic personalities span four generations, ranging from the work of Lea Nikel, who was born in 1918 in Zhitomir, the Ukraine, and immigrated to Palestine when she was a young child, to that of Nir Hod, who was born in Tel Aviv in 1970. The range of styles, perspectives, and the

degree of innovation encompassed by the artists demonstrate how decisively their work undermines any monolithic cultural or aesthetic point of view. If they see themselves in the reflection of Israeli art of past decades, it is in terms of their actively deconstructing or reinterpreting past art forms and conventions.

Yet, as this exhibition seeks to capture the flavor of a turbulent, splintered time in Israeli society by considering a stylistically and ideologically diverse group of artists, we note that, despite the plurality of styles, the works disclose a common sensibility. Political and social references may be indirect or explicit, but this is an art that projects an inner turmoil—without nostalgia or comfort. Even in the work of artists who express intensely personal concerns, if we dig more deeply we may find an elegy for the victims of war or a response to the stress of life in Israel. Artists who live in a society that continues to struggle for its very survival cannot ignore the tension that pervades their lives and thoughts. It is little wonder that each work has an undercurrent and is committed to the expression of uncensored opinions.

In this exhibition catalogue, leading Israeli art, cultural, and social critics write about the role and place of Israeli art within their own society and in the world at large. Their observations are insightful: they describe how the gaze of Israeli artists may be turned toward exploring personal identity or societal issues, such as the problem of survival in an antagonistic political climate, the ongoing absorption of new immigrants, internal clashes of culture and communities, a deterioration of collective and idealist values, and the loss (or success) of the Zionist dream that mobilized the creation of the state. Israel today is also increasingly multicultural and diverse—with its different ethnic communities that include recent immigrants from Ethiopia and the former Soviet Union, polarized religious and anti-religious factions, a more vocal Arab minority, and men and women concerned with the implications of

gender all seeking self-definition, influence, and expression within the culture. Most of these different assertions of identity run counter to the normative, traditional, and, in the past, collective view. And since many Israeli artists believe it is their role to confront cultural stereotypes and to eschew preconceived loyalties, they often project a subversive or marginal point of view—directly or implicitly—in their critiques of sociological, political, ecological, ethnic, ideological, and aesthetic issues.

By the very nature of their work, Israeli artists who follow the subversive path create a wedge between themselves and their public—including an American public that, for reasons of nostalgia and sympathetic identification, or to justify their own support of the country, may prefer to celebrate Israel's achievements rather than focus on its problems and failed hopes. Contemporary Israeli art that ignores, baffles, or makes fun of its audience runs the risk of offending that audience.

A goal of this exhibition and catalogue is to portray the vitality and innovation that characterize the work of artists who currently live in Israel. We did not aim to select artists who fit into stylistic molds, or whose work could simply be identified as Israeli. Rather, the art reveals a configuration of seemingly eclectic, often competing, visions and attitudes toward Israeli life that has emerged and evolved in the years following Rabin's death. This group exhibition cannot claim to represent the range or complexity of Israeli artistic development and thinking even during this brief three-year period, and this selective survey is intended to suggest the existence of a much greater reservoir of mature and rich material. Furthermore, the curatorial choice has been made by an outsider, an American, based on personal appraisal resulting from countless conversations with Israeli artists, curators, and critics, along with viewings of the art. The choice of artists—which includes both emerging and established figures—was intended to assert the importance of artists demonstrating risk

and originality.

The omission of certain artists and works should also be noted. Ibraham Nubani (plate 35) is the only Arab Israeli artist shown in the exhibition. Another Arab Israeli artist who was asked to participate in the context of the 50th anniversary of the founding of Israel refused on the grounds that it would be construed as an endorsement of official policies toward Israel's Arab citizens. Clearly, artists who share this viewpoint have asserted their cultural, religious, ethnic, and political identity in Israel as Arabs. Another voice unrepresented in this exhibition is that of the Orthodox Jewish community, in part reflecting the secularism of the Israeli art world; the religious communities have produced very few artists in Israel. One whom we had hoped to present declined to participate because we did not select work that expressed his view of "Israeli values."

If we have identified certain broad and inclusive themes in the art, they are obviously loose and fluid, and they overlap and interconnect. Nevertheless, the works represent cultural perspectives and concerns ranging from political and social critiques to the most personal passions and preoccupations. For certain artists, there seems no choice but to focus on a society under stress by capturing and illuminating its pervasive anxiety, tension, and disquiet. As engaged citizens, these Israeli artists understand that a work of art is not ideologically neutral, but implicitly takes a position. Works of art can be used to comment on specific social or political situations or to convey a particular message. They also employ the more explicit rhetoric of shock that overturns conventional expectations, forcing us to confront widespread concerns about security, military service, war, terrorism, occupation, and the ongoing battle for territory. Military themes are prominent in Israeli life and art, understandably since mandatory service swallows up three years in the lives of men (and two years for women), in addition to one month each year—until age 55

for men and age 50 for women—spent in the reserves. The Limbus Group's *Embroideries of Generals* (plate 4), for example, deconstructs the mythic Israeli war hero and leader—and cult of the macho male—by displaying portraits of former Israeli Army chiefs of staff printed on needlepoint canvas, a material traditionally associated with domestic life and women's decorative crafts.

There is a strong emotional tone to much socially- and politically-oriented art. Feelings of anger, fear, pride, shame, and violence are expressed in many of these representations, which appropriate images from media sources as diverse as advertising, TV, video, and journalism. The success of this kind of political art can be measured by its ability to express the disequilibrium, ambiguity, and uneasiness that are experienced daily in Israeli society in an almost palpable visual form. The painter David Reeb uses his art to draw attention to his country's political activities. Rather than making subjective statements about the situation, he renders directly the images published in Israeli newspapers and shown on television (plate 7). In this way, Reeb's work asks penetrating questions about the ways in which perception is shaped and socially conditioned.

Artists in other countries are outspoken about the quality of life, but their criticism is rarely expressed more dramatically than in Israel. Even when the artist supplies the most explicit references to the local Israeli context, the situation of the Israeli creative artist cannot be fully understood without a lived awareness of the ubiquity of death and bereavement in the society. Works that convey the implicit danger in even the most apparently innocent aspects of daily life may encode more subtle messages, as in Gideon Gechtman's sculpture that takes fragments of a shattered porcelain figurine—an innocent object of virtuosity— and combines these broken pieces with the strength and inviolability of bronze to create six new figures that are identical in form, but not material, to the original object.

The assassination of Yitzhak Rabin, the ensuing change of government, and the slowing down of the peace process negotiated in Oslo are events that have had a decisive influence not only on the political life of the country, but also on its cultural development. Any consideration of art during the last few years must acknowledge the deep sense of loss surrounding Rabin's murder. That moment on November 4, l995, destroyed the extraordinary aura of hope and liberation that had flowered briefly in Israel. Rabin's image integrated the characteristics of the *sabra* leader in an uncanny way: tough on the outside, sensitive and humane on the inside. The shock and sadness that gripped Israeli society following his assassination gave rise to artistic expressions unprecedented in their scope and volume, illustrating how in death Rabin seems almost to have become detached from reality and transformed into an abstract symbol and mythic figure. Nothing would be the same after that violent act. At first there was a vendetta against the religious nationalists. Eventually Israelis realized that healing had to take place among different groups in the nation, and they sought shared, nonpartisan forms of expressing their grief and solidarity. Hence the powerful paintings by some of the older and more established artists in the exhibition— Lea Nikel (plate 13), Moshe Kupferman (plate 11), Igael Tumarkin (plate 8), Raffi Lavie (plate 12), and Pinchas Cohen Gan (plate 9)—in which an abstract vocabulary effectively transmits their profound sense of loss.

It is difficult to draw the line between what is an environmental issue and a sociopolitical one in this art. A distinct body of work reveals a shift away from the explicit preoccupation and physical engagement with the land, geography, and territorial issues, which were prevalent in the 1970s and '80s in Israeli art, to the use of objects both real and simulated as metaphors for different perceptions of reality. By using images of material structures such as buildings and roads—or real objects such as road signs—as the focal points of paintings, sculpture, installations, and photographs, Israeli artists alert us to the hazards lurking in

a modern technological society. For example, in the installation piece by Ariane Littman-Cohen (plate 19), the juxtaposition of neutral physical objects, such as bottled mineral water, bags of earth, and cans of air, acquires a broader significance by their labeling, respectively, as "holy water," "holy land for sale," and "holy air"; not only are the objects given an ideological context, but that context is simultaneously undermined by the shift in focus from the sacredness of the Holy Land to the commodification of its natural resources. In a different framework, a discarded road sign by Ido Bar-El (plate 21) symbolizes the loss of its public authority and meaning through the act of being defaced by the artist. Whether the photographs taken by Roi Kuper of an abandoned army warehouse in the Golan (plate 16) are environmental or sociopolitical, judgment is implicit. Until the 1973 war, when such sites began to be neglected, they were among the most secret locations in the country and afforded the great respect then given to the army. Now, as suggested by Kuper's title for this series, *Necropolis,* such warehouses may be seen in the context of a cemetery, or "necropolis," a monument to a former moment of glory. In Simcha Shirman's photographs of a road around the new city of Mody'in (plate 22), an ironic twist of fate is suggested in the opposition between the wide-open landscape dominated by seemingly innocuous cactus, and the new city, represented by fortress-like walls of brick and plaster that impinge on the land. In these works, images and objects acquire meaning through their context: to understand each work of art is to perceive how images may be transformed by the environment in which they are placed.

The content of much recent art in Israel has been deeply affected by ideas about the meaning of land and how the natural environment is experienced and defined in a culture in which the sanctity of the land has been ingrained as a central concept of the collective Zionist myth. Deliberately stripped of their traditional associations by inserting subversive elements, Uri Tzaig's postcards of forests (plate 15) and Moshe Ninio's honey jar (plate 18) transform this promised land of blooming desert and of milk and honey, revealing how these cultural myths have been replaced by an endangered landscape that threatens the possibilities for personal freedom. At the same time, Micha Ullman creates habitats made of iron and sand that incorporate earth as a component material (plate 23), expressing his deep personal connection to the land and to the physicality of the earth itself, however threatened or threatening it may be.

In contrast to environmental and socially explicit images, works that explore the artist's personal experiences, in the form of an autobiographical or created persona, figure prominently in Israeli art today. The act of turning away from the conflict and tragedy of national life to explore personal realities has led many artists to confront gender identity, religion, ethnicity, and their own personal autobiographies—concerns that demand introspection and consciousness of self. Their art reflects a turning inward and detachment from national, political, and broader environmental issues.

The aftermath of the Yom Kippur War in 1973, with its agonizing loss of life and of confidence in Israel's military invincibility, resulted in an upsurge of disquiet and self-criticism, deepening the political involvement and cultural identity crisis of Israeli artists and widening the gap between the avant-garde and the political establishment. Around the time of the invasion of Lebanon in 1982, many Israeli citizens openly began to question the necessity of armed conflict as a way to resolve the Israeli-Arab struggle; most Israeli artists identified with the political Left and joined in its opposition to the war. In subsequent years, Israelis increasingly have come to value the irreplaceable individual at least as much as worship and defense of the land. Yaron Ezrahi, the political scientist and social critic who is a contributor to this catalogue, puts it this way:

"Because the loss of life is an absolute loss, the gradual spread of the values of individualism has forced Israelis to juxtapose 'there is no other place' with the no less compelling imperative 'there is no other life' " (*Rubber Bullets: Power and Conscience in Modern Israel* [New York: Farrar, Straus and Giroux, 1997], p. 254).

Often highly personal or filled with the commonplace details of life, this art questions the nature of identity —real, assumed, invented, cultural, national, and personal. The fable-like autobiography of Nir Hod's constructed works (plate 3) leaves unclear whether the ambiguous "I"—neither completely male or female, fictional or authentic—is actually the artist or a symbolic alter ego. Nir Hod's work, as noted, and the photographs of Adi Nes (plate 5) explore gender identity—such as the macho male role—in a specifically Israeli context, that of the military. Are these men the rugged, tough, invincible Israeli soldiers of 1967 legend, or are they pretty boys posing and letting off steam, albeit with an ironic twist of fate thrown in? Merilu Levin's transformed ready-mades (plate 31) project a subtle but provocative feminist stance that comments at once on gender, sexuality, sex-role stereotyping, and the role of women in Israeli society. They turn everyday objects such as a cakepan, an iron, or a bathroom shelf into intimate self-portraits that project a wry sense of humor while making their point about "women's work." Ethnic identity issues are embedded in the paintings of Ibrahim Nubani (plate 35), which combine identifiable cultural images and abstract patterns to convey an uneasy synthesis of East and West derived from his experience as an Arab Israeli living in two worlds.

When artists look to myth, ritual, and religion as a source, they find multiple means of expression. Belu-Simion Fainaru's mixed-media installation (plate 27) ironically confronts the conditions that secular urban life imposes on Orthodox Jewish religious practices in Israel today. A traffic light continues to operate on the Sabbath—in violation of Orthodox observance—demonstrating the municipality's rejection of Orthodox demands that city regulations conform to Orthodox beliefs. Pesi Girsch's photographs (plate 24) reveal the other side of this dichotomy in the insular atmosphere of an Orthodox neighborhood in Jerusalem where life is portrayed as untouched by the rules or customs of the modern city. It is interesting to note that when these artists infuse their work with charged cultural content, they generally do so in a revisionist or critical spirit and from a distanced point of view.

Personal revelation is present to varying degrees in all of the works that explore facets of individual identity. The artwork and personal experiences are as diverse as the artists themselves. Hilla Lulu Lin's video (plate 30), reflecting a provocative female vision of reproduction, depicts a whole egg yolk rolled from the artist's mouth, down her arm, and back to her mouth in a continuous cycle. Nurit David's paintings (plate 32) juxtapose familiar places (a schoolroom, a stairway—both transitional spaces) and members of her family in an autobiographical narrative that has both psychological and iconographic meaning. Despite their intimate and idiosyncratic visions, however, not all works containing personal references impose a subjective or distorting filter on the surface of reality. Some art may possess an aura of objectivity, as, for instance, Israel Hershberg's realistic representation of immediate reality in his portraits or still lifes (plate 33).

All of the participants in this exhibition and catalogue make use of contemporary aesthetic strategies to create work that conveys the complexity of life in Israel. A major concern is the very role and function of art and the language of artistic communication. In Israel, and throughout the international art world, installation and object-based art have become the media of choice, while technology has made the spread of video art inevitable, especially since its visual effects offer opportunities for artistic experimentation. Video appears frequently as an element of mixed-media works; as an independent form of documentation;

or as a mode of transmitting an evocative film with its own internal references. Because of its extraordinary capacity to capture perceptual detail as well as personal nuance, photography has developed as an important and influential medium. As it acquired an independent artistic identity, photography departments were established at the major art schools and museums in Israel. The heightened institutional interest in film, video, photography, and computer arts has stimulated much activity in these fields.

The politicization of art seems to go hand-in-hand with rejection of the more traditional media of painting and sculpture that may be better suited to neutralizing political and social content. While a number of artists throughout Israel continue to paint and to draw, currently these methods lack the force and impact of a collective phenomenon, as was evident among the pioneering artists of preceding generations. The current mixed-media work also favors an array of language and conceptual strategies that include irony, satire, and parody. Joel Kantor photographed a toy donkey in front of a shabby building on a Jerusalem street and gave it the ironic title *Waiting for the Messiah, Jerusalem.* This absurd image, with its legendary associations of the Messiah's arrival on a white donkey, undermines cultural stereotypes and alludes to the debased aspirations that emerge now in Israel's everyday life. On the surface everything is stable, secure, normal; but in fact an existential uncertainty prevails.

Like the game played without rules in Uri Tzaig's video, this new Israeli art may convey the absurd and intangible forces at play in human life, whether represented by means of simple forms and directness of execution or by complex structure and rarified abstraction. It is difficult to find an art that is more persistent or burrows deeper into an existential consciousness. Reflecting a fresh intellectual rigor and confidence, contemporary Israeli art addresses themes that are major constructs within the culture, enhancing our perception of Israel today by expressing its history, ideals, conflicts, fears, and hopes.

1

Have you
 noticed
 a prominent shift in
 artistic focus
 from collective
 or communal responsibility
 to an assertion
 of personal identity
 and private feelings?

 Are the
 political instability and
 social change
 pervasive in Israel in recent years
 expressed in new
 artistic interpretations?

The State of Art in Israel Today

Perspective I

ADAM BARUCH

Contemporary Israeli art is not entirely free of the emotional need to affirm the accepted Zionist narrative. Even harsh critical expressions, such as those of Raffi Lavie (plate 12) and Moshe Gershuni (plate 10), in their joint Tel Aviv exhibition following Yitzhak Rabin's murder, are not exempt from this narrative. Theirs is a critique that is a sort of mourning. I would add: a mourning within the nuclear family.

If we remember that at the height of late Israeli modernism not a single case of patricide was to be found, we understand that even the most unadulterated personal artistic course pursued by one artist or another maintains a link to the collective. Raffi Lavie did not "murder" his artistic progenitor, Yosef Zaritsky. On the contrary, Lavie engaged in a long and penetrating artistic dialogue with Zaritsky. The lyrical abstraction that preceded the early Lavie and early Gershuni was a vital address for these young artists, and not a remote and fleeting historical entity. And so, on the whole, the trajectory of Israeli modernism, ranging from Zaritsky, Avigdor Stematsky, and Yeheskel Streichman in the 1940s to Raffi Lavie and Moshe Gershuni in the 1980s, encompasses a more or less unified "modernist family." It is a modernist collective that examines Israeli life and society by means of an almost collective poetics, with few nuances that reflect generational or international influences. Nevertheless, the individual voice, private and not prototypical, is very present in contemporary Israeli art and, ironically, may be its best representative.

Does a critical and analytic return to the myths of Zionism, along with a general mistrust of the Zionist ideals, constitute a real disengagement from these myths and from this Zionism? Do painters, like the new historians, offer the Israeli public a foundation for creating a future history, one divorced from current assumptions? Not necessarily. This is only an artistic attempt to erect a new model that runs counter to the ruling canon—one that focuses on treatment of the

Perspective II

TALI TAMIR

"Actually, there was only one big, all-encompassing collective. That was the picture. The individuals amplify the whole, and there's no dispute about it," wrote the photographer Dalia Amotz, a member of Kibbutz Givat Brenner, in an essay on kibbutz photography. "Of course, there were deviations from the norm, but they were not photographed because they were whispered, not spoken out loud. The 'together' was spoken out loud." Although these words describe kibbutz society at its inception— and they certainly represent the compulsory collectiveness of the communal kibbutz society of the 1940s and '50s— one can extrapolate from them truths about Israeli society at large, which was founded on sweeping and deeply felt ideological principles. Unlike other immigrant societies, Israeli society aimed to paint all its human factors in the blue-and-white colors of the Zionist ideology. Only lately, from a distance of fifty years, can we gradually see those instances and domains in which Israeli society had consciously sacrificed all expressions of difference and individuality for the sake of preserving a strong and uni-form ideological front, and charging with positive energy the engines of the enormous settlement project that it had to fulfill. They are discovered daily, the other voices—not only the voices of North African Jews, who suffered primarily from economic discrimination, but of the other groups on whom Zionism, the only entrance ticket to Israeli society, was forcibly imposed—for example, Holocaust survivors, who repressed their "diasporic" side in order to integrate into Israeli society.

In its early days, Israeli art suffered from two critical handicaps in its development. The first was the absence of a visual tradition and the need to opt for one that would accommodate its needs. The second was the ideological commitment to the Zionist ideal and to establishing a visual connection with the new-old land, the Land of Israel. Besides the recurring depiction of pioneers and labor, this ideology was expressed in an entire genre of *Eretz Yisraeli* landscapes that created a virtual screen on

Arab or minority—religious, middle-class, new immigrant—"other." The new historians—through research, texts, revisionist readings of political processes—are constructing this new model with more political and intellectual stamina than the Israeli painters. We are still more of a textual society than an imagistic one. With the exception of Yitzhak Danziger's *Nimrod,* 1938 (fig. 1)—the sculpture portraying the biblical hunter as a "Canaanite" mythic figure, which became a symbol of everlasting Israeli youth—not even one artistic image has penetrated the consciousness of the Israeli public. The imagery of Zaritsky, who for years was the local pope of the arts, is accessible only to the artistic community. Overall, it can be said that "the Israeli painter" is essentially still an "experiential," and not an "intellectual," personality.

Larry Abramson, in *Tsova,* his series of the early 1990s, returned to the Arab village that Zaritsky did not "see" when he painted Tsova, from 1970 to 1984 (fig. 2), as a landscape. In other words, Abramson

which an ideal image of the nation-in-progress was projected: romantic, joyful, full of greenery and mountain curves, optimistic, and, for the most part, conflict-free and inviting (fig. 3). This is how *Eretz Yisrael,* the Land of Israel, appeared in works by the painters of camels and olive trees, as well as in the semi-abstract paintings, of members of the New Horizons group—the lyrical abstract painters who viewed themselves as modernists in the broadest sense of the term (fig. 4). Even without the Orientalist narrative, the promised land was still there—sweet and cuddly, hospitable and colorful, but without any correlation to actual reality.

Undoubtedly, this obligatory ideological experience became a sort of trauma from an artistic point of view. The individual, private, intimate perspective was not given appropriate legitimacy by a society whose aim was to create a collective identity. And so it happened that the multiplicity of expressions and identities along with the tension inherent in the political conflict were swept to the margins of consciousness and masked by collective genres. One of the most important developments in Israeli art of the last two decades is the creation of space for internal contradictions, paradoxes, and local conflicts, and the fragmentation of artistic expression—through form and content—into a plurality of artistic statements. The moment in which Israeli art began to undermine its uniform identity and discover the residue of those latent identities that had not been completely suppressed is a crucial one. Today it cannot be denied that irrespective of whether one is a Zionist, post-Zionist, or even anti-Zionist, being Israeli means that one's consciousness is

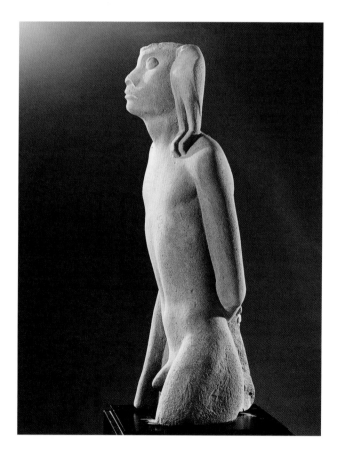

FIGURE 1
YITZHAK DANZIGER
Nimrod 1939
Nubian sandstone, 37 ⅜ x 13 in. (95 x 33 cm)
Collection The Israel Museum, Jerusalem

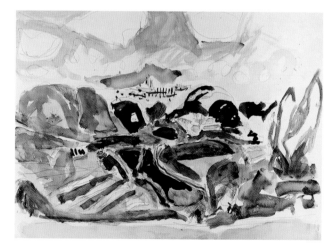

FIGURE 2
YOSEF ZARITSKY
Tsova 1974
Watercolor on paper, 17 ⅜ x 21¹⁵⁄₁₆ in. (44.2 x 55.7 cm)
Collection The Israel Museum, Jerusalem

painted the Arab village that was there, and that Zaritsky had ignored. This was an artistic, intellectual, and political act unique to the history of early modern Israeli painting. And, coincidentally, the reaction to Abramson's decision to expose the Arab village, and thus undermine Zaritsky's aesthetics by presenting it as ethically lacking, was quite muted. Abramson's act was suffocated by the daily papers in the closet of art criticism.

much more complex than the blue-and-white model of the mythological Israeli (fig. 5). The eternal youth of the *sabra* in sandals, who "emerged from the sea" to deny his diasporic past, has evolved into a more mature consciousness, one that is absolutely indispensable to a nation of immigrants. This is a stratified and multifaceted consciousness in which the Israeli layer envelops the residue of former generations, not only memories of the Holocaust and oppression, but also the other landscapes, other languages, costumes, and customs—Western or Oriental, but essentially just Other. The conflict between the identities of victim and conqueror, the contrast between contemporary and ancient history, the turn from a masculine society to one that expresses a longing for gentleness and forgiveness, the struggle between a theological and secular tradition— all result in art that has discarded both its idealistic and universal facade. Today's Israeli art, at its best, is restless and disturbed. It strives for self-expression at all costs and seeks a visual language that will connect the common idiom to local and private codes.

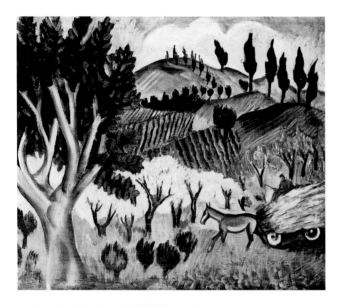

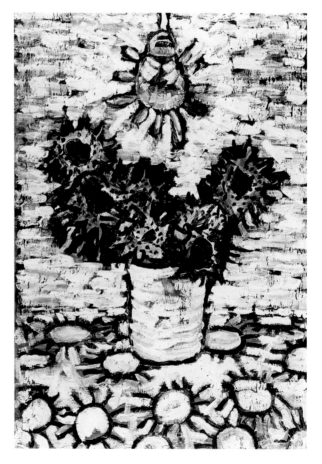

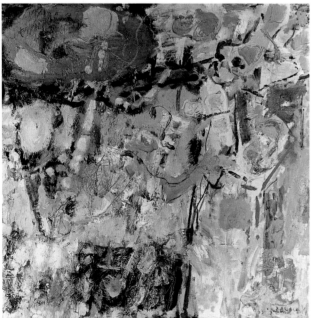

FIGURE 3 (*top*)
ISRAEL PALDI
Israel Landscape 1928
Oil on canvas, 24 ¹³⁄₁₆ x 28 ¾ in.
(63 x 73 cm)
Collection The Israel Museum, Jerusalem

FIGURE 4
AVIGDOR STEMATSKY
After a Landscape 1963
Oil on canvas, 39 x 39 in.
(99 x 99 cm)
Collection The Israel Museum, Jerusalem

FIGURE 5
ASIM ABU-SHAKRA
Cactus 1988
Oil on paper, 35 ⅞ x 27 ³⁄₁₆ in. (91 x 69 cm)
Collection The Israel Museum, Jerusalem

2

Israeli society
at the end
of the twentieth century,
like that of other nations,
is confronted with a confluence
of compelling issues.
Among them are
concerns about cultural
and religious pluralism;
the social impact of
feminist, sexual, and
ethnic identities;
the effects of new technologies;
and a redefined sense of
responsibility to the environment,
particularly with regard
to the original Zionist dream
of "reclaiming the land."

How, specifically,
have these issues been represented
and interpreted in
Israeli artistic discourse?

Every comparative study of contemporary Israeli art and that of Western countries must acknowledge the fact that Israeli art has, in effect, been banished from Israeli history. Israel is now 50, and no catalogue, anthology, or comprehensive study examining these fifty years of nationhood refers to Israeli art as a real "source" for understanding social, cultural, political, and linguistic processes. Israeli society, as it is represented by its historians, regards Israeli art as tangential to Israeli history. Period. They do not view it as inspiring or documenting or contributing to a common Israeli journey.

Whereas Israeli theater, fiction, and poetry reinforce political and cultural developments and dilemmas, Israeli art has not succeeded in validating even one such endeavor or event. The theatrical productions of Moshe Shamir, during the 1950s, and Hanoch Levine and Yehoshua Sobol, in the 1980s, legitimized discussion of the dilemmas surrounding such issues as Israeli identity, Israeli-Jewish identity, generational tension between fathers and sons as formulated in the *akedah* theme, and attitudes toward peace and war. The poetry of Dalia Ravikovitch and Binyamin Hrushovsky, in the 1980s and '90s, validated the debate about Israel's stance toward the new immigrant and the Palestinian "Other." Israeli literature for generations has stood at the center of the debate on Israeli identity.

However, not one of the intellectual, ethical, and political currents in Israeli art has had such an effect. Not Igael Tumarkin's series *Crusaders;* not Michael Druks's series *The Television Cover-ups;* not Tamar Getter's *Tel-Hai;* not Michal Ne'eman's *The Eyes of the Nation* (fig. 6); not Motti Mizrachi's *Pioneer;* not David Reeb's *The Intifada and Suburban Slumber;* not Menashe Kadishman's *The Sacrifices;* not Pinchas Cohen Gan's *A Tent in a Refugee Camp.* Not one of these aesthetic-political works or series has stimulated broad discussion or propelled sociopolitical processes.

From this isolated stance, which is becoming even more so these days, one can nonetheless point to artistic trends and to artists who are speaking in a distinctively contemporary voice. Commenting on feminism, gender, ecology, and religious and political openness, they make use of the most current technological

In this era of new historicism, when the Zionist story is told from points of view other than that of institutionalized Zionism, an era in which a central position is replaced by a multiplicity of individual statements, the aesthetic-philosophical domain is necessarily pluralist. Israeli culture has no escape at this time from the broadening and, simultaneously, fragmenting of its outlook. In this sense, Israeli society finds itself on common ground with other cultures that, in this age of postmodernism, have discovered the advantages of pluralism.

Yet the more interesting question is whether or not Israel is mature enough for real pluralism, which is based on tolerance and acceptance of the Other, or whether it is still fixed at a stage of retribution and diatribe with regard to the central ideology. This unforgiving perspective is apparent, for example, in the work of artists of North African origin who are busy uncovering their own private history of oppression at the hands of those they refer to as "the Zionist-Ashkenazi authorities," instead of engaging in autonomous modes of ethnic expression, free of the aggression cultivated during years of insult and discrimination. Another example concerns feminist works of art. Rather than addressing the specific situation of women in a militaristic-masculine society, and thus offering a grounded and sensitive pluralist vision, feminist artists often resort to provocative displays of female body parts to assert the presence of gender. Contemporary homosexual artists in Israel also choose to focus narrowly on expressing their exclusive masculine desire, in contrast to a predecessor, Moshe Gershuni, who, from the start of his sexual identity crisis, initiated a cultural trend centered not on the phallus and male body, but rather on a conflicted psychic identity with its multiple layers of consciousness (fig. 7).

The militant impulse of Israeli culture, however, does not give way even when the culture seeks pluralist expression. The cultural field looks more like a battleground than a series of calm and confident stands. The nationalist-religious perspective, for example, does not have a visible artistic dimension, aside from graphic propaganda. As for the art of the political Right in Israel, it remains unknown, if only because it is not at all accessible to the secular Left. The latter does not bother to give it

and intellectual tools, including the intentional language of art.

Despite all that has been said so far, it is important to realize that the concepts prevalent in the Western art world do not possess exact Israeli equivalents. In Israel, they acquire a distinctive and concrete Israeli meaning. The connotation of "religious" in Italy is not the same as in Israel. The American Hannah Wilke, an artist of the 1980s, arrived in Israel in the 1990s. No Israeli artist has gained the "monk status" of Cy Twombly. No Israeli artist maneuvers through the culture with Willem de Kooning's theoretical baggage. No Israeli art has crossed national borders for years unless the artist actually emigrated from Israel to Europe or the United States. Israeli feminism is a secular rather than "religious" concept. In other words, the ethical and behavioral codes considered religious in Israel have not yet been subject to feminist critiques. The concept of modern technology in the service of art is always lagging five or six years behind the West, primarily because of financial constraints. The theoretical discussion of Israeli art takes place in only one monthly publication. Until recently, Israeli art was not even recognized as a proper subject for a doctoral dissertation. The entire Israeli art market yields an annual revenue of approximately 24 million dollars.

visibility in the cultural space that it controls—yet another aspect of the absence of real pluralism in Israeli culture.

It is important to understand that the question of pluralism in contemporary Israel is absolutely critical. If one supports or identifies with the Right's stance on questions of religion, politics, democracy, and social behavior, one is in danger of losing the entire Zionist project. What is at risk today in Israeli culture is not this or that artistic style, but the fate of the Zionist endeavor that has totally revolutionized our view of Jewish culture. The attempt to create a secular, democratic Jewish culture—a paradoxical creature—is in real danger. If the religious Jewish culture, well known for its phenomenal capacity to survive, succeeds once again in reversing the revolution and returning the religious criteria to center stage, the Zionist endeavor will fail, even if Israel continues to exist. Today it is clear that even if Zionism has succeeded beyond expectations in its settlement project, its cultural offering to itself and to the region is still in process. An artistic expression of the basic cultural struggle to reconcile secular and religious ideas is found in the use of biblical texts by young Israeli artists who were raised within a secular society, but continue to view the Bible as a foundational text of their ethical and linguistic culture. In Israel, the Hebrew language, notwithstanding its ambivalent coupling with the English language, is an important and influential cultural foundation. Whereas English is perceived as a link "outward"— to the world at large, to universal culture—Hebrew is perceived as a mode of self-expression, a declaration of Israel's presence at the margins, but still maintaining an aura of a conceptual and spiritual center. The use of bibli-

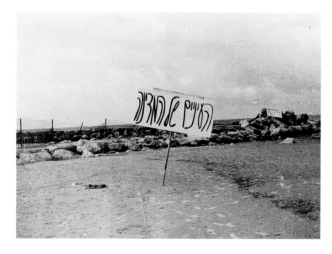

FIGURE 6
MICHAL NE'EMAN
The Eyes of the Nation 1974
Photograph, 19 ¼ x 23 ⅝ in. (49 x 60 cm)
Collection Tel Aviv Museum of Art

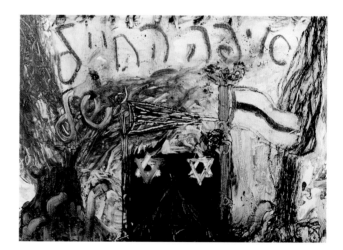

FIGURE 7
MOSHE GERSHUNI
Where Is My Soldier? 1981
Acrylic on paper, 39 x 55 in. (99 x 139.7 cm)
Collection The Jewish Museum, New York

A preeminently immigrant society, Israel is centrist and fairly conservative with regard to aesthetic developments. In this context, our familiarity with the art of new immigrants, both from the West and the East, is quite limited. It is thus possible that new and vigorous trends will emerge among the diverse groups within the Israeli population.

The political and emotional stance toward *Eretz Yisrael*—the land, the nation, patrimony, the peace process, maximalists, minimalists—is not in itself a central concern of important Israeli art, and is usually not explicit. Most Israeli painting that is openly political does not rise above graphic art.

To the question "Is the classic Zionist redemption of the land figured in Israeli art in an affirming or negating fashion?" I have no clear answer. I prefer to comment through the following cultural metaphor: the leading artistic figures of *Eretz Yisrael* and early Israel viewed themselves as artist-laborers, taking part in the Zionist endeavor and in the conquest of the desert; members of the younger contemporary generation see themselves as promoting a private career in art. In other words, the cultural processes affecting society at large are present in the art community as well.

cal texts by relatively young Israeli artists establishes a reference to biblical ethics as interpreted from a humane and contemporary point of view, and to fundamental problems in the relationship between Jew and non-Jew, the Jew and the Other; the story of Hagar's expulsion is an example.

The question of responsibility to its regional surroundings was examined by Israeli art in light of the ongoing Jewish-Arab conflict, the central political conflict that has accompanied the Jewish settlement of *Eretz Yisrael* from its inception. During the 1920s and '30s the Arab presence in Israel was perceived as an integral part of the local landscape—an Oriental entity that merged with the landscape and was not viewed as provocative. But with the escalation of the conflict, the Arab presence became a factor that could not be ignored. The visual arts found it difficult to designate an appropriate medium to deal with the issue, and were always in conflict between an identification with the Zionist perspective and a growing distress over the increasingly militant Israeli occupation. The Intifada years and the war in Lebanon have conflated this problem, not only because of the conflict itself, but also because of the need to confront the perpetual presence of death in Israeli society, death that has gradually lost its self-justification. The Israeli occupation has created a critical issue for Israeli art. To a certain extent, it did not allow artists the much-needed freedom to sink into their private worlds, and brought back the old resistance to cultural conscription characteristic of the early Zionist years. Explicitly political art is not, therefore, a developed chapter in the history of Israeli art. Whether out of fear of being superficial, or because of a lack of distance from traumatic events, many artists choose to comment indirectly on the political situation and to give expression to fear, violence, death, and injury in a subjective and oblique manner. Even the works of David Reeb (plate 7) that deal openly with images of war and occupations possess a restrained quality: they always include abstract, non-figurative elements that alert the observer to the limits of art. We are not speaking of the moral ambition of a work like *Guernica,* which remains confined to the museum halls, but rather of an artist who points out a certain reality that is happening around us. The refusal to deny, the resistance to enveloping the harsh Israeli reality in luminous tinted veils, as did the lyrical abstract painters of the 1950s—this in itself is a meaningful stand. Simultaneously, the opposite stance, which seeks to fortify itself within the personal realm and refuses to allow this reality to undermine one's sanity or snatch away one's right to privacy, is a mainspring of Israeli art of the recent past.

3

Israel is a
country
situated
on the
periphery of
Western
cultural centers.

How is the
East - West dialectic
reflected in
recent Israeli art?
Have attitudes
changed or
modulated as a
result of
increased international
travel and contact,
including
Israeli participation
in major
international art
expositions?

During the 1970s the West German Joseph Beuys had a special status. His influence was widespread. He provided an accessible model of an artist, of art, of exhibition, media, and publicity. The Beuysian syntax, the artist's relationship to German history and to the materials of autobiography, his political-activist dialogue, the culture and wisdom of his artistic production—all were very present in Israel. In the late 1980s there were quite a few intense discussions of Marcel Duchamp. Robert Rauschenberg's visit to Israel and his exhibition in the early 1970s were indicative of the continued interest in his work. Julian Schnabel and David Salle left a distinct social and aesthetic impression. But everything in Israel is absorbed through a local cultural filter. Beuys was transformed into an almost local Beuys, and so on. In other words, the periphery franchises a Western entity and adapts it to its own circumstances, much like the franchising of Italian ice cream in Israel, which meets the requirements of kosher dietary laws.

The deeper dilemma, however, does not lie in adopting Beuys's creative approach but in the question "Who are we?" In the domain of the visual arts, are we merely a Western consulate in the Middle East? In other words, are we formulating an identity, mentality, and style that are foreign and alien to the region? And if not, how does modern Western aesthetic thought, which rules us, relate to the here-and-now of the Middle East? And if the global model is East-West, what is Eastern in us? Is the sculpture of Ya'acov Dorchin, who represented Israel in the 1990 Venice Biennale, viewed by Western eyes as a contemporary extension of Anthony Caro or Mark di Suvero? Or do these Western eyes also detect an authentic Israeli aspect, a kind of East in this East-West template? Does Menashe Kadishman (fig. 8), returning to Israel after many years in the West, import into Israel a purely Western mode of thought, or rather a concoction of Western and Israeli ingredients? Was the gradual change in the composition of the board of directors of major museums in Israel (now more financiers than intellectuals) merely an adoption of the American model, or was it also an internal conceptual shift that has influenced the museums themselves as keepers of memory and dictators of taste?

An important step in the "normalization" of Israeli art, and its ability to overcome naive adolescent fantasies, is for it to recognize its actual place on the artistic map. This is not art with its body in the East and its spirit in the West. Rather, its body is in the West and its twin spirit wanders restlessly between East and West, engendering a third entity: from within the Jewish tradition, which is conscious of the center, a peripheral art emerges that acknowledges the anxiety of distance. The fact that this art is produced alongside that of the international centers has lately been seen in a constructive light, as a positive influence rather than as a source of derivativeness. Can Israeli art expect an international audience to pick up its cultural codes in the same way that it masters the Chinese aesthetic idiom? Does not Israeli art suffer to this day from the misconception that it is a Western art, when in actuality it is nurtured by entirely different sources? Is the encounter between Israeli and international art at international exhibitions productive, in the sense that it reveals something of the

FIGURE 8
MENASHE KADISHMAN
Sheep 1979
Silkscreen, oil, and acrylic on sheet, mounted on canvas,
60 ½ x 80 ½ in. (153.7 x 204.5 cm)
Collection The Jewish Museum, New York
Gift of Selma and Stanley I. Batkin

How, in fact, are Israel's fifty years of participation in the Venice Biennale to be summarized? As curator of the Israeli component of the 1988 and 1990 Biennale, what is the weight of my personal testimony—that Venice does not display real patience and sympathy toward representatives of the periphery? What is the value of Israeli participation in the São Paolo Biennale, Documenta, or in biennials taking place in Turkey and South Africa? Within the last fifty years, approximately 180 Israeli artists have participated in these events. In Turkey, they exhibited alongside up-and-coming Turkish and international artists, and, in Venice, with the likes of Jasper Johns and Hans Haake.

From whose viewpoint should such exhibitions be evaluated? From the viewpoint of Venice, or of Documenta, or from an Israeli perspective? And can the international eye of Venice see anything distinctive in the character of Israeli art? Is it indeed modern art in its eyes? Is it merely an extension of the West—of Europe or America? What happened to the Israeli master Yeheskel Streichman who displayed his abstract work in Venice during the 1950s? One source of Streichman's creative inspiration was Paris, although Paris and the rest of the world were already absorbed in new and disparate styles of painting. Did Streichman seem to the Venetian eye a charming anachronism? Did Streichman himself return from Venice different or changed? I do not think he returned to Israel as a new Streichman. Yet dozens of other Israeli artists who came back from Europe and the United States, having absorbed new values, modes of thinking, and techniques, greatly influenced the Israeli artistic landscape. Of particular importance are the photographers of the 1980s, who rapidly accelerated the modernization of Israeli art photography.

The East? The Third World? Us? The act of ongoing identification with the Third World is characteristic of artists such as Zvi Goldstein, who explored the theme of peripheral culture vis-à-vis the West. Identification with the East, within this East-West framework, is expressed in popular and folkloric art in an intuitive and naive manner, and in some contemporary art as a political and value-laden fiber that is not always made explicit. The mainstream is distinctly Western, according to its own ambitions, the formal questions that it poses, the exhibition channels that it seeks, and the critical jargon it employs.

undeniable complexity of Israeli culture? Or does not the international audience still expect to enjoy the placid exoticism of a new country somewhere in the Orient?

Fifty years after Israel's declaration of independence, the most urgent project for Israeli art is to gain recognition as distinctive art with its own particular complexities that are neither Oriental-exotic nor Western-universal. The deep connection between Israeli and Western culture, based to a certain extent on the historical place of Jews at critical junctures in world cultural history, provides Israel with a nuanced understanding of its cultural distance from the West as well as the influence of its Middle Eastern surroundings. In other words, Israeli art cannot be judged by the same criteria as art of other peripheral cultures. While Ghanaian art, for example, was nurtured for years by the African tradition, Israeli culture was nurtured by a range of historical centers encompassing both East and West. This trend of thought pertains to Israeli culture in general, and is the only perspective from which to appropriately understand the relationship of Israeli art of the last two decades to the West. Unfortunately, the Israeli cultural authorities do not make available the massive investment needed to expose Israeli art to the world on a continuous rather than an accidental or sporadic basis. I hope that the current exhibition will be received as representative of Israeli art as it is today: located at the pivotal intersection between private and public, political and intimate realities. This is the margin that defines periphery as an alternative center, not as a footnote to the central text.

Reflections on
Art, Power, and Israeli Identity

YARON EZRAHI

Assembling and exhibiting individual works of art with the intention of saying something about a specific society as a whole raises, of course, difficult questions of interpretation. These questions are compounded in the case of Israel, a society still in formation, which has been continually transformed by waves of mass immigration, relentless conflict with its neighbors, and deep internal contradictions. Beyond the changes, it is nevertheless possible to discern certain trends and persistent themes that may provide the contours of a more comprehensive view of contemporary Israeli art.

In the course of the last two decades, and especially during the 1990s, Israel has been slowly but steadily shifting from what may be described as the early epic phase of its history, the period of heroic nation-building, to the increasingly post-epic era of a more ordinary political and cultural life. In the public life of Israelis, the rhetoric of struggle, sacrifice, and liberation has been gradually weakened by internal controversies on policies concerning the Arab-Israeli conflict and by preoccupation with domestic conflicts between religious and secular Israelis, corruption in high places, and issues of economic policy. Along with the decline of ideological fervor, Israeli artistic expressions have become more explicitly critical as well as more individualistic, more private, more self-reflective, and more diverse.

At the end of this century of Zionism, individual artworks seem, therefore, less likely to be readily joined in supporting generalized observations about Israeli social characteristics, or shared communal orientations, of the kind that appear to mark earlier periods. Still, we can, and probably should, consider this very shift toward more diverse and more subjective artistic expressions to be a feature of a more general social process of corrosion of real or illusory collective Israeli sensibilities, the fragmentation of the imagined Israeli social whole by the forces of an incipient Israeli individualism, and the deepening division of Israel into several distinct subgroups.

In some respects, this post-epic phase in Israeli culture and politics—the diminished power of the master narrative of a monumental history from catastrophe to redemption—has involved a profound reordering of social and private values. If, in the idealistic climate of the earlier revolutionary periods, criticism of a "sacred" institution like the Israeli army, or an embrace of the ordinary, the mundane, the materialistic, and the subjective often appeared subversive, in recent years such positions have become more legitimate and acceptable. This change has significantly altered the cultural and political contexts within which Israeli artists have been relating, first, toward the persistent theme of the still-unsettled issue of corporate as well as individual Israeli identities—questions about what is Israel and who is an Israeli—and, second, toward the distinct yet related issues of the place of military force and violence in both Israel's conflict with the Arabs and within Israeli society itself.

In the course of the first half-century of Israel's existence, Israeli artists were intensely engaged, directly or indirectly, in composing and recomposing the collective portrait of Israel as well as the personality of the Israeli as an individual. The record of Israeli art reveals a wide spectrum of responses to the issue of Israel's identity in relation to East and West, religion and secularism, nationalism and democracy, cosmopolitanism and regionalism. A recent exhibition at The Israel Museum in Jerusalem on Orientalism in Israeli art provides an illuminating account of the complex interaction between European—or Western—and Eastern elements in the formation of "Israeliness" (Yigal Zalmona, *To the East: Orientalism in the Arts in Israel,* 1998).

Yigal Zalmona, the curator of this exhibition, surveys the diverse explorations of the Oriental theme in Israeli painting. In the early decades of the twentieth century, Jewish artists who lived in the *yishuv,* the pre-state

community that later became Israel, introduced a European-Orientalist perspective on the East as a Romantic, innocent, rural, and often erotically enchanted oasis surrounded by primordial desert. This idyllic view was often invoked by artists whose idealization of native figures expresses an urge to connect with and become a part of this ancient homeland. Abel Pann, for instance, painted biblical figures as local Arabs or Bedouins, thus intimating a common ancestral origin (fig. 9). In later years, a wavering between attraction and repulsion toward the East was strongly affected by fluctuations in the evolving conflict between

Jews and Arabs. Waves of violence often shattered idealized, attractive versions of the East, recasting the Arab as a threatening stranger, the ultimate Other—a rural, often primitive, vital but violent identity that is the polar opposite of the urbane, sophisticated, yet frail European Jew. These were not, however, necessarily mutually exclusive identities, as is demonstrated by the tendency of Jewish guards in the early settlements to dress like Arabs as well as the merging of Western and local features in the later cultural construction of the Israeli-born Jew, the *sabra*, as an ideal. This dual attitude of both attraction and repulsion toward

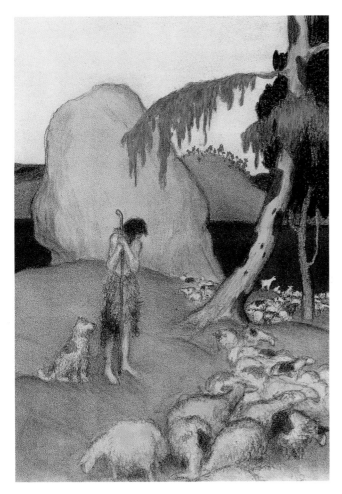

FIGURE 9
ABEL PANN
And Abel Was a Keeper of Sheep from the series **Genesis**
Color lithograph, 13 x 9 ½ in. (33 x 24.1 cm)
Collection The Jewish Museum, New York
Gift of Dr. and Mrs. Abram Kanof

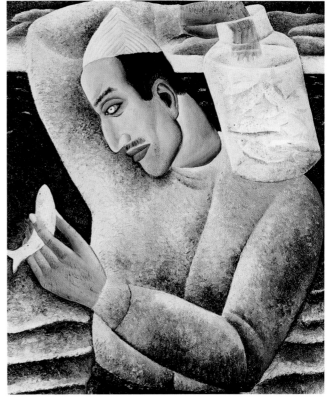

FIGURE 10
REUVEN RUBIN
Goldfish Vendor 1928
Oil on canvas, 29 ½ x 24 in. (74.9 x 70 cm)
Collection The Jewish Museum, New York
Gift of Kitty and Harold J. Ruttenberg

Arabs was echoed and often reproduced in the shifting orientations of European (Ashkenazi) Jews toward "Oriental" Jews (from North Africa and the Middle East). The latter have been alternatively seen as a link to the neighborhood or a threat to cherished Western values and sensibilities. So, rather than clear-cut choices between Western and Eastern identities and values, one is likely to find in Israeli art a much more dynamic interplay between sometimes opposing and sometimes converging qualities.

During the first decades of statehood, the violent conflict with the Arabs encouraged a tendency among Israeli artists to close their eyes to the ruined Arab villages and the displacement of the Arab population or to assimilate them as a natural feature of picturesque Oriental landscapes. In some respects, Israeli artists have facilitated the creation of an ideological-perceptual divide between *history* as the sphere of the Jew as an actor, a builder, a *halutz,* a pioneer or an agent of modernity, and *nature* as the sphere of the Arab, an authentic native, a part of the exotic, Oriental landscape, as exemplified in the works of painters like Reuven Rubin (fig. 10) and Nahum Gutman.

In more recent decades, such views have been modified, as Romantic, Oriental, visual utopias came to be regarded as implicitly concealing the violent conflict between the two peoples and its resulting human toll. More recent Israeli art expresses much more reflective, self-critical, and often politically explicit perspectives on the Israeli-Arab experience, indicating a growing ambivalence toward the occupation and the effacement of Arabs by expanding Israeli cities and roads. The increasingly sharp criticism of the use of military force against the Arabs, reinforced by the experience of the Intifada, has generated more complex, multilayered artistic works that convey the tensions between narratives of liberation and occupation, construction and ruin—as evoked, for instance, in Dina Shenhav's *City* (fig. 11). The parallel existence of such dichotomous consciousnesses, the kind of involuntary interactions that occur between them as well as the blindnesses and ambiguities that they have produced, are revealed, for example, in the works of David Reeb (plate 7). Within the more intimate territories of Israeli feelings, these kinds of ambivalence and ambiguity lead to a powerful indictment of military values, as illustrated in the work of Israeli artists such as Erez

Harodi (fig. 12), who, with his collaborator Nir Nader, turns the decorative white ribbon that held the memorial medal received by his family following his father's death in the Six-Day War into a hangman's noose dropping down on the father's photograph. Micha Ullman's works (plate 23) provide a more abstract play on the themes of death and destruction; using red soil and sand, they convey subtle messages about the earth as simultaneously the subject of this bloody contest, symbol of human perishability ("from dust to dust"), and the process through which it comes to bury ruins and efface the memories of former lives.

A central, perhaps dominant, underlying impulse in much of contemporary Israeli art is then the demystification of military force and sense of the unresolvable tragic tension between the liberating and destructive aspects of the use of force in the short history of Israel. Contemporary Israeli art can reveal, therefore, the kinds of sensibilities and emotions that have nourished the changes that consistently led an Israeli majority to support the peace process.

FIGURE 11
DINA SHENHAV
City 1997
Charcoal on wood, 70 ⅞ x 78 ¾ x 16 in. (180 x 200 x 40 cm)
Courtesy of the artist, Tel Aviv

Now that the Arab we once dislodged from history to nature has again been historicized, now that the sight of the Arab and the Arab voice can no longer be avoided, Israeli art has become a very significant arena for Israeli reassessment of the meaning and role of force in the formation of Israeli identity and, more generally, in Israeli culture and politics.

Gilad Ophir's work subtly invokes the kind of images and associations Israeli gunners may have seen and experienced while shooting at the enemy. His silver prints (plate 17) show the remains of wrecked, once luxurious German-made Mercedes cars serving as targets in army shooting ranges. For the soldiers using these ranges, the target links the Germans to the Arab cabdrivers from East Jerusalem and the West Bank who drive Mercedes cars that were first introduced into the Israeli experience following the Six-Day War. Despite the questionable grounds for associating Israel's Arab adversaries with Germans, it is precisely the attempt, following World War II, to establish such a link, as many Israeli soldiers have testified, that proved so effective in motivating Israeli gunners to shoot at their adversaries. Adi Nes's color photographs of Israeli soldiers hint at a more recent development in Israeli attitudes toward power and military values. One photograph depicts a yarmulke-wearing Israeli soldier, apparently of Oriental background, flexing his muscles. In this picture, the exposed part of his body seems to fully identify with the uniform. Plate 5 shows a group of Ashkenazi-looking soldiers who appear somewhat hesitantly to be clapping for an unseen subject. They wear their uniforms loosely, and one of them allows his white T-shirt to show beneath his unbuttoned army shirt. A one-armed soldier who cannot clap his hands is sitting like a living statue in their midst, wearing his army trousers with only an undershirt on top. The undershirts seem to challenge the uniform, just as the private person within resists the soldier without. This photograph brings to mind a few lines from Hermann Broch's *Sleepwalkers*: "for it is the uniform's true function to manifest an ordained order in the world, to arrest the confusion and flux of life, just as it conceals whatever in the human body is soft and flowing, covering up the soldier's underclothes and skin" (New York: Pantheon, 1947, p. 21). Together, the two photographs may convey to Israeli viewers a "politically incorrect" statement about the widening gulf between ambivalent and non-ambivalent attitudes toward military force identified with different groups of Israelis, or two distinct contemporary versions of Israeli identity.

This tense coexistence of opposing viewpoints also underlies the introduction of the theme of Rabin's assassination into many contemporary works. These works reflect the recent extension of issues of power and identity from the context of the Israeli-Arab conflict into the domestic arena featuring relations among Jews. They reveal more widely the strains between the corporate identities of Israel as a Jewish and a democratic state and, as such, constitute a discourse on the nature of the Zionist enter-

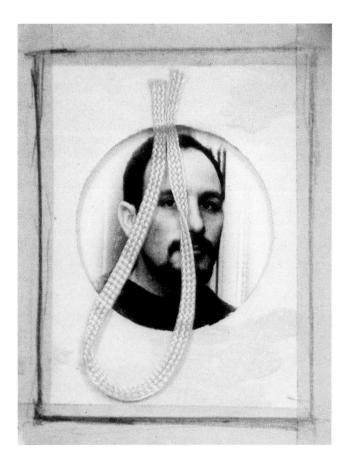

FIGURE 12
EREZ HARODI
Memorial Medal—In Support of the Fallen Soldiers 1993
Photograph, paper, and rope, 11 ⅞ x 7 ⅞ in. (30 x 20 cm)
Courtesy of the artist

prise. The fact that Yitzhak Rabin, who was the living embodiment of the *sabra,* the authentic, secular, Israeli-born Ashkenazi, was assassinated by an Orthodox Yemenite Jew inevitably (although unfairly) casts the lines of the domestic conflict—perhaps too sharply—as a struggle, with strong ethnic connotations, between nationalistic religious and liberal democratic values. One can then discern hints of how the issue of the uses of force and the various components of corporate and individual Israeli identity interact and configure in contemporary Israeli art. Beyond this focus, the Rabin assassination produced, of course, wider and more diverse reverberations in the Israeli psyche, some of which are discernible in recent artwork. They include works that function as indictments of political violence, works that seem to serve as moral warnings, and works that juxtapose the reality of the wounded Israeli democracy with Herzlian dreams of the innocent, progressive, liberal Israeli (plate 9). The assassination seems to be associated with powerful undercurrents in Israeli culture. In this connection, it often appears that art has allowed much more direct expression of feelings, and much sharper criticism, than politics.

Along with these developments, perhaps the most significant force working within, and reshaping, Israeli culture today is the gradual rise of individualism, the articulation and evolution of numerous Israeli selves amid the ruins of broken collectivist utopias. In the early decades, expressions of individuality were bound to emerge through friction with collective mentalities and to trigger pressures for group conformity. Uri Katzenstein's *Love Dub* (plate 29) may echo this new sensibility with an ironic look at the overburdened Israeli individual charged by the collective with "missions impossible." But with the relaxation of such external collective pressure in recent years, the focus seems to have been shifting to more internal domains. The urge to escape the searing light of the Israeli sun, the omnipresent gaze of the community, has been gradually replaced by a more inexhaustible exploration of the interior shades and deeper personal sources of subjectivity. Decades of epic-redemptive politics and Zionist normative collectivism have created, in Israel, generations of Jews cut off from what Michel Foucault terms "technologies of the self," the strategies and techniques developed, especially in Western

culture, to form selves that are differentiated from collective, often hidden, clusters of consciousness and power. In the context of this poverty of Israeli cultures of the self, contemporary Israeli artists are playing an increasingly more important, even crucial, role in exploring the deeper sources of subjectivity and the languages of its expression. If, in the early stages of this process, the self may just be moved to proclaim its name, as in Roi Kuper's *Abandoned Army Camp* (plate 16), by inscribing it in anonymous landscapes, at later stages the search turns, as in Nurit David's works, to the more private origins of selfhood.

Nurit David (plate 32) works with childhood memories as if she desires to save the link with the presocialized self, to locate a moment in personal history that precedes adult consciousness. While this is clearly not a uniquely local option, it takes on very specific meanings in the context of a community like Israel, in which collective memory is a moral commandment and an institutionalized state cult. Still, even this legacy has recently been transformed as the official memorial days for the fallen soldiers and the victims of the Holocaust have included public citation of the private names of the dead.

In any society, of course, issues of identity and power fundamentally remain unsettled. Also, the opposition between East and West, religion and secularism, collectivist nationalism and liberal-democratic values in Israeli culture and society are often too complex and ambiguous to warrant dichotomous categorizations. Still, by virtue of the particular ways in which Israeli artists have reflected and commented on the Israeli experience, we can often gain subtle insights into underlying sensibilities and emotions that rarely find their way to the international public projections of Israel in politics and the media.

The Plates

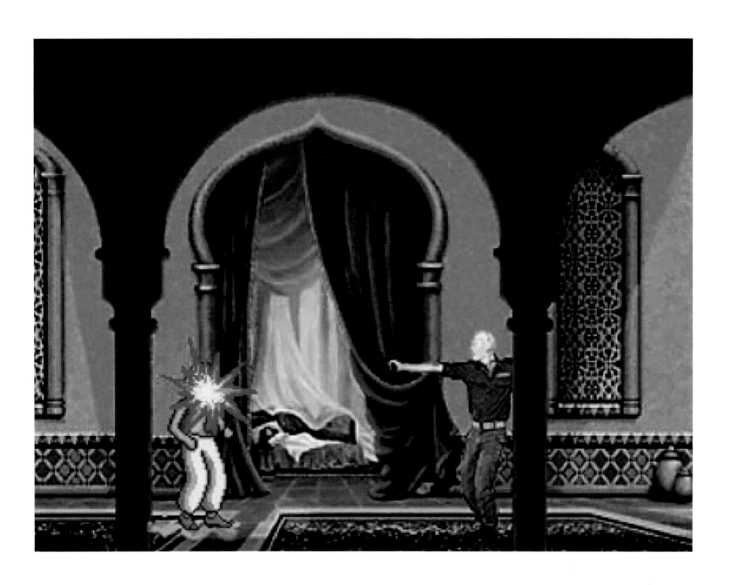

PLATE 1
AYA & GAL
Prince of Persia 1995
Video
10 minutes, 30 seconds

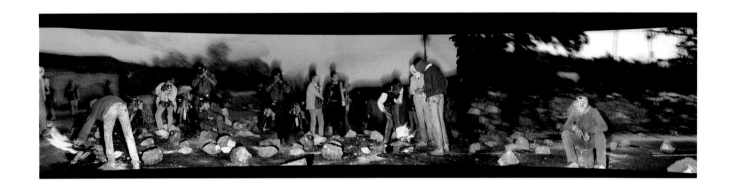

PLATE 2
BARRY FRYDLENDER
Birth of a Nation 1997–98
Digital transparency on photographic paper, mounted on Plexiglas, stainless steel, and fluorescent light
19 ¹¹⁄₁₆ x 78 ¾ x 6 ¼ in. (50 x 200 x 17 cm)

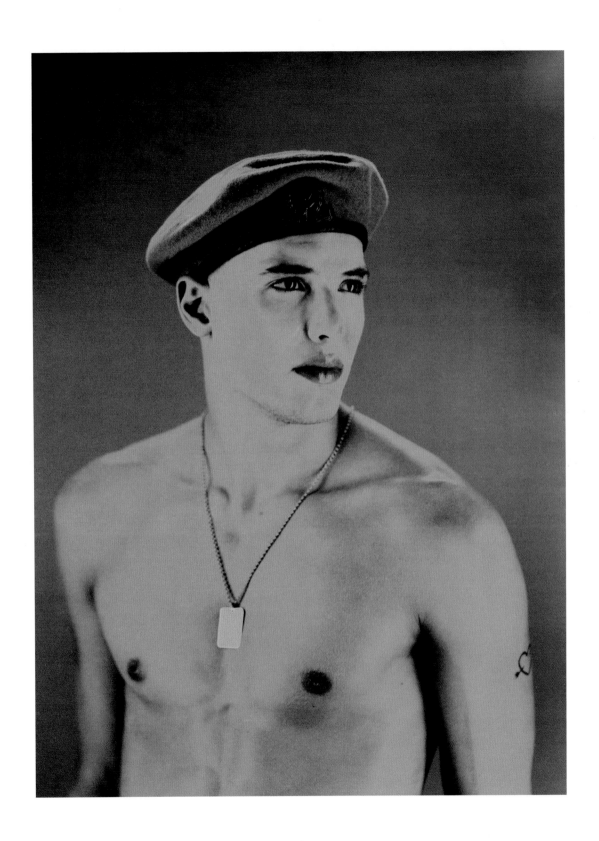

PLATE 3
NIR HOD
Israeli Soldier 1998
Black-and-white photograph on silver paper
63 x 47 ¼ in. (160 x 120 cm)

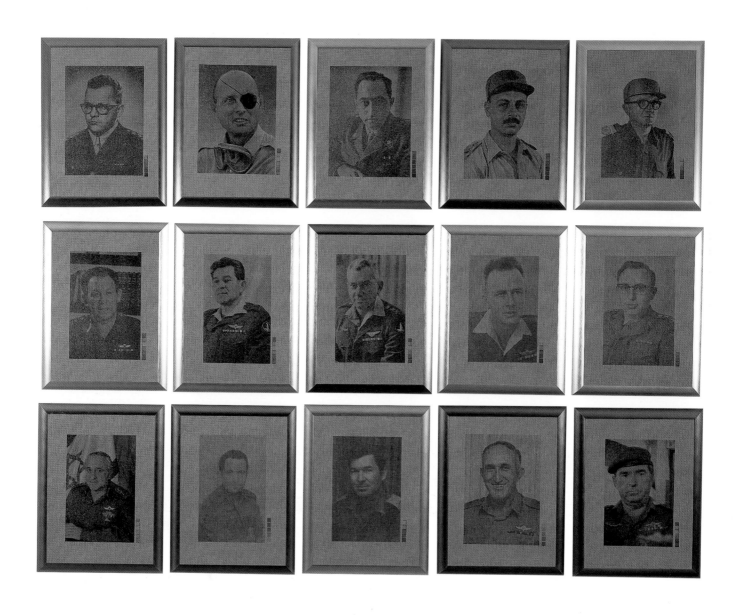

PLATE 4
LIMBUS GROUP
Embroideries of Generals 1997
Digital print on canvas
Fifteen works, each 11 x 17 in. (27.9 x 43.2 cm)

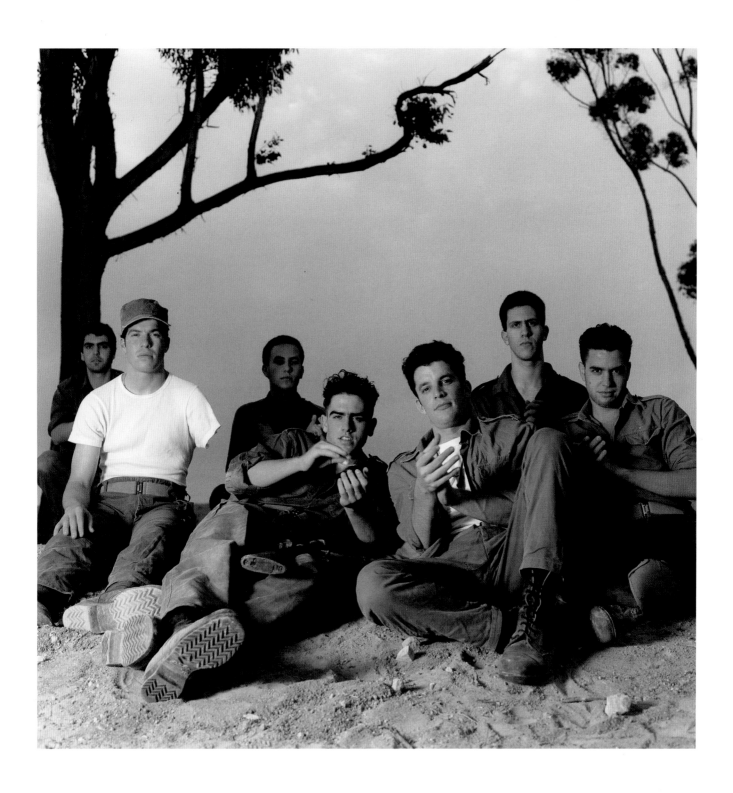

PLATE 5
ADI NES
Untitled 1996
Color photograph
35 ½ x 35 ½ in (90 x 90 cm)

PLATE 6
DORON SOLOMONS
My Collected Silences 1996
Video
4 minutes

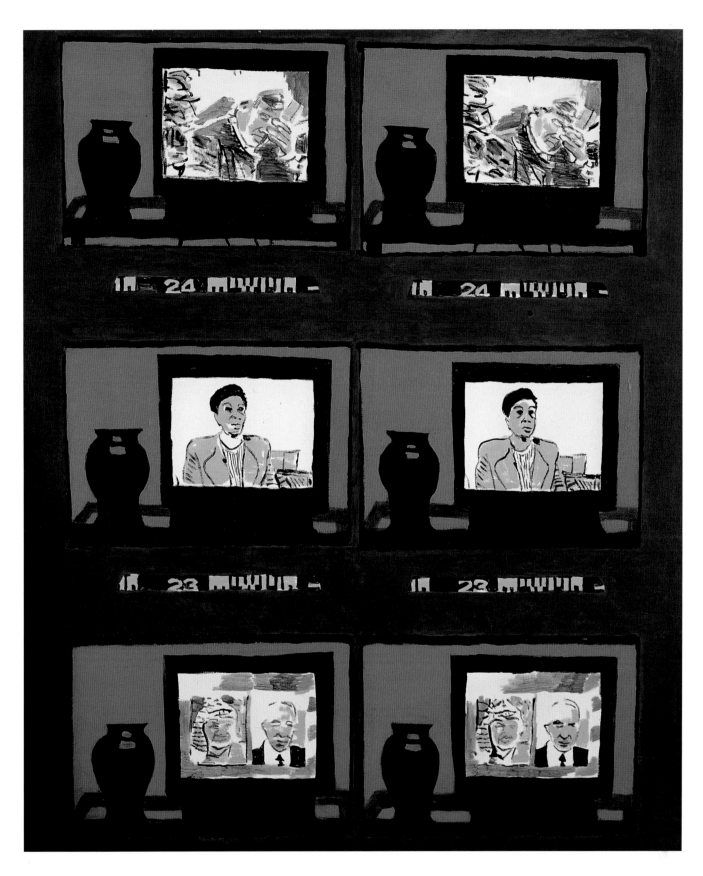

PLATE 7
DAVID REEB
Orange-and-Blue TV Contact Sheet (Sour Grapes) 1996
Acrylic on canvas
63 x 55 ⅛ in. (160 x 140 cm)

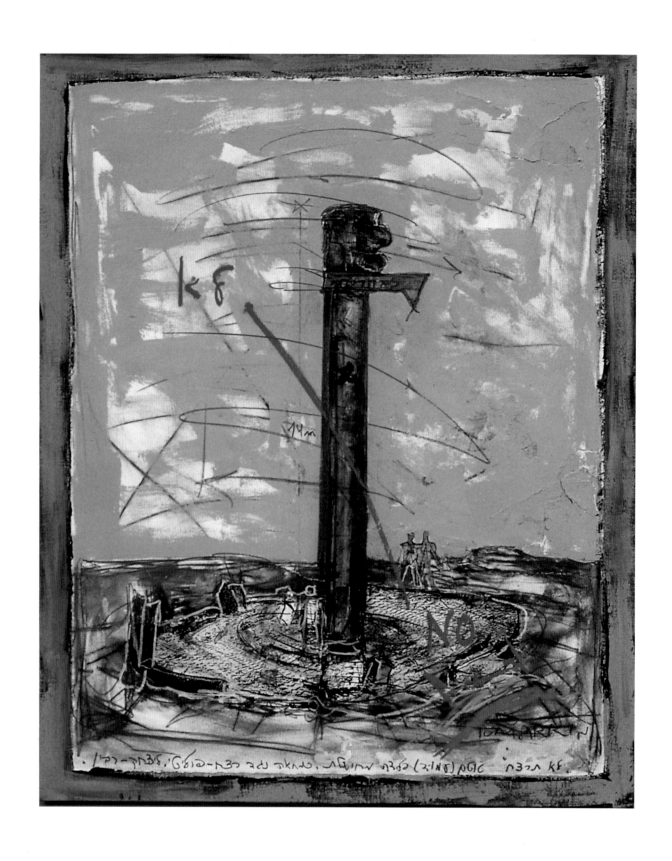

PLATE 8
IGAEL TUMARKIN
You Shall Not Kill 1996
Mixed media on canvas
50 ⅜ x 37 ¹³⁄₁₆ in. (128 x 96 cm)

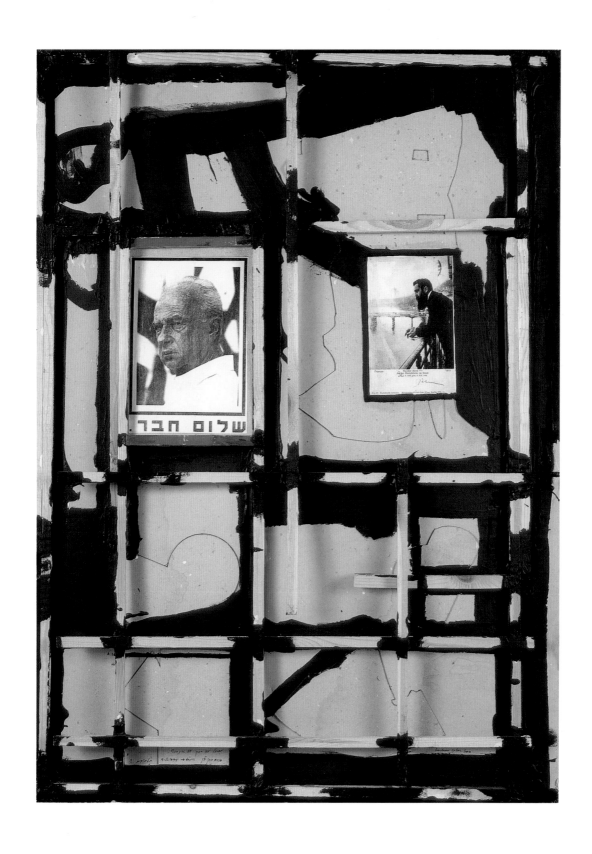

PLATE 9

PINCHAS COHEN GAN

From Herzl to Rabin to Infinity 1995

Cardboard, acrylic, wood, and Xerox

41 ¾ x 30 x 2 in. (106 x 76 x 5 cm)

PLATE 10
MOSHE GERSHUNI
After the Shiva 1995
Mixed media on canvas
39 ⅜ x 39 ⅜ in. (100 x 100 cm)

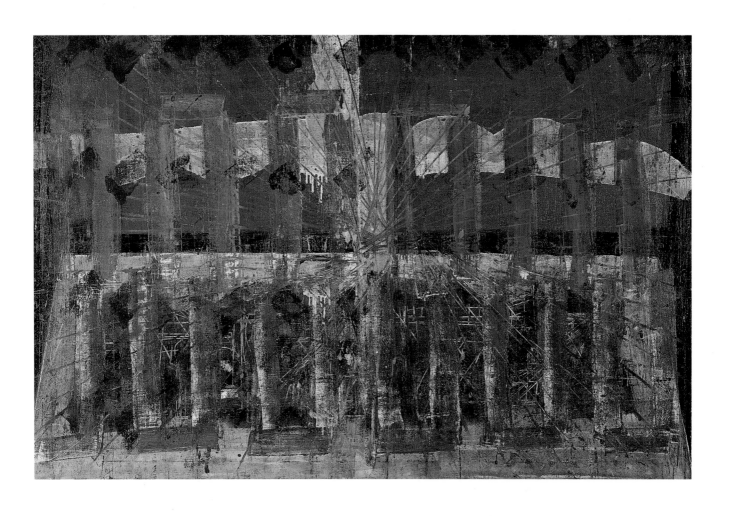

PLATE 11
MOSHE KUPFERMAN
Mourning for Rabin 1996
Oil on canvas
51 ⅛ x 76 ¾ in. (130 x 195 cm)

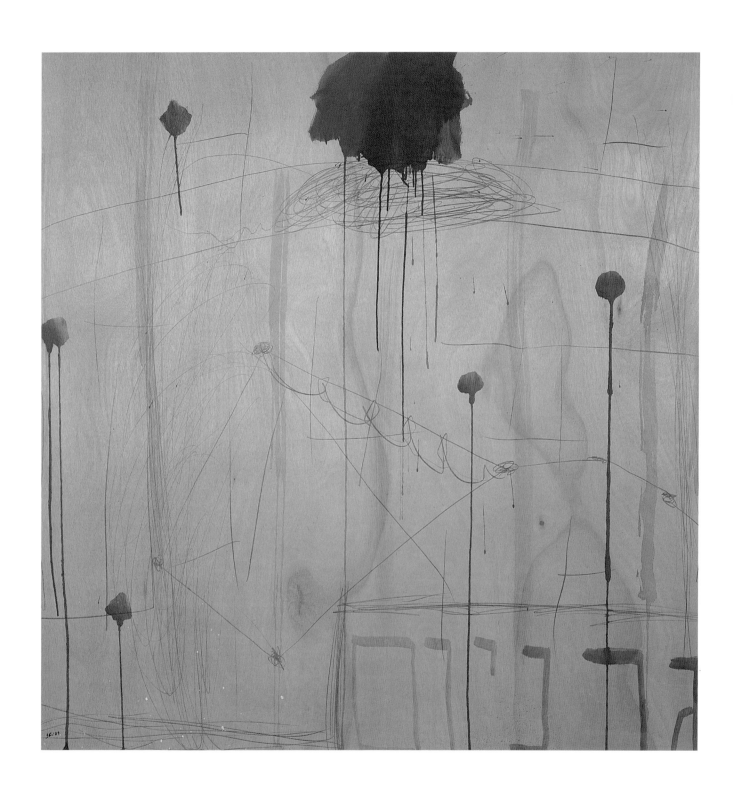

PLATE 12
RAFFI LAVIE
Untitled 1996
Acrylic on plywood
49 ¼ x 48 in. (125 x 122 cm)

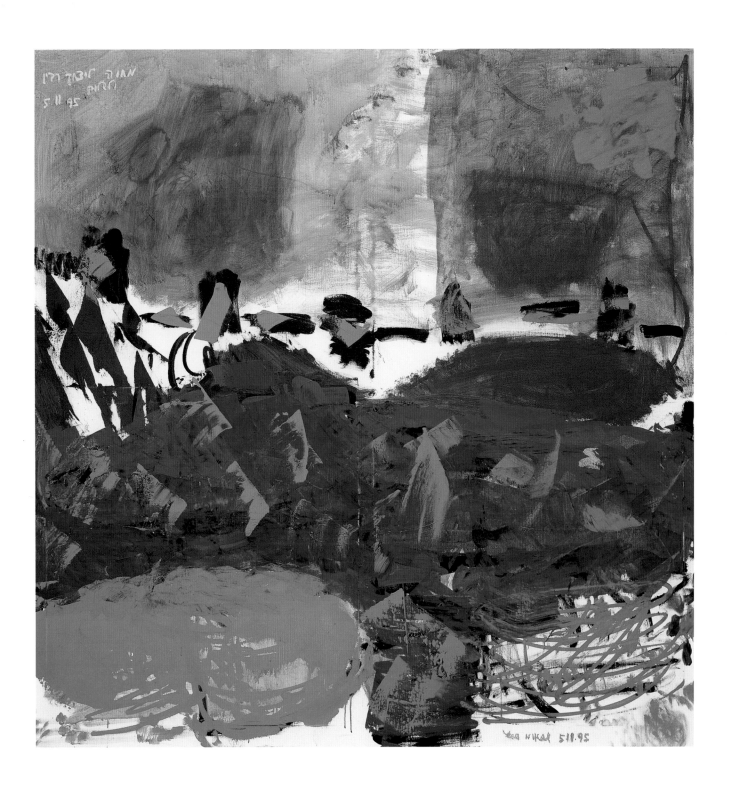

PLATE 13
LEA NIKEL

Gesture for Rabin and for Peace 1995
Acrylic on canvas
65 x 65 in. (165 x 165 cm)

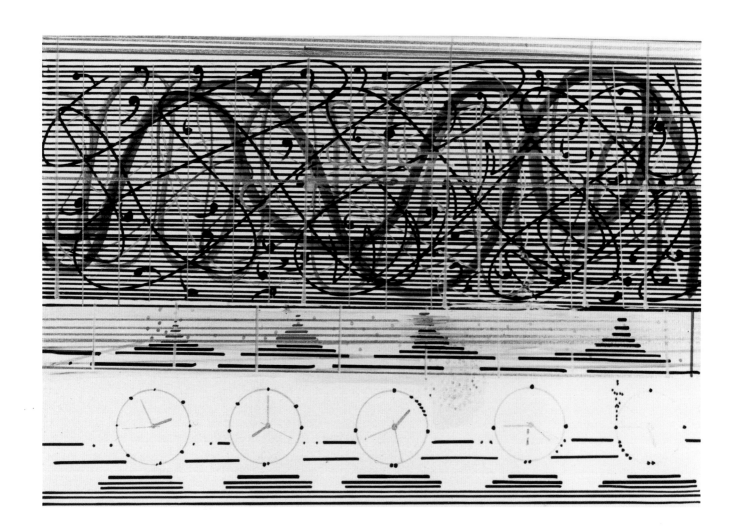

PLATE 14
AVNER BEN-GAL
Lines 1996
Mixed media on canvas
19 5/16 x 27 3/8 in. (49 x 69 cm)

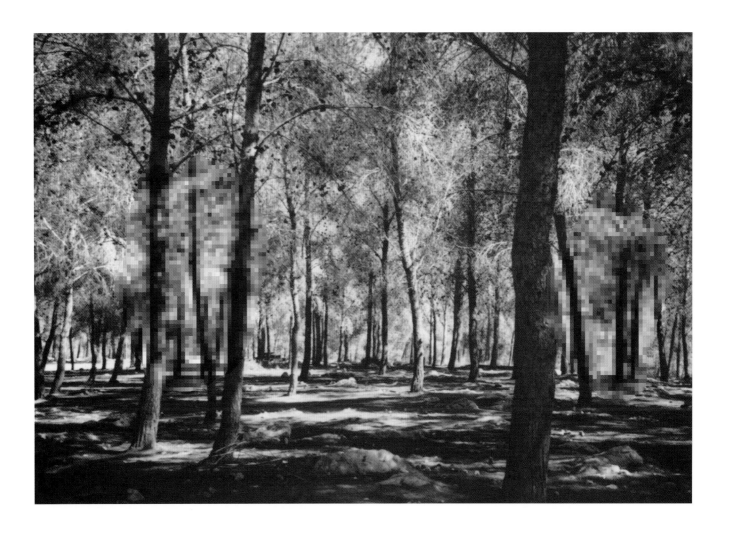

PLATE 15
URI TZAIG
Forest–Postcard Rack 1995
Postcards and postcard rack
Postcards: each 4 x 6 in. (10.2 x 15.2 cm)

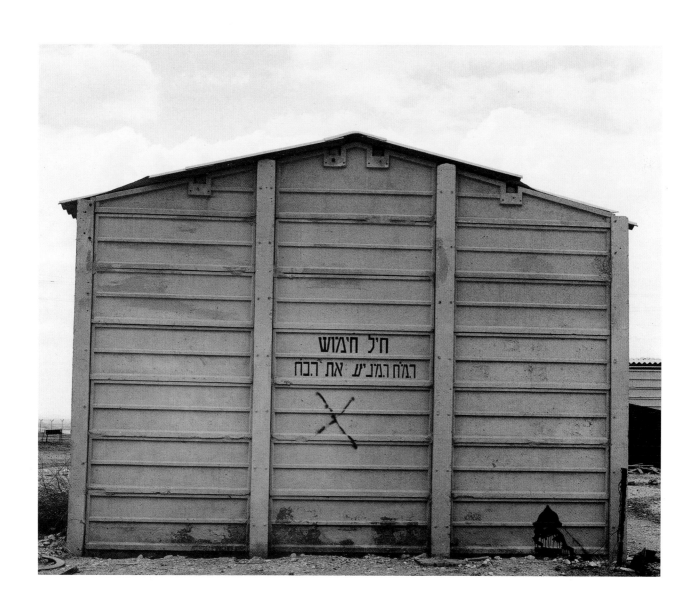

PLATE 16
ROI KUPER

Abandoned Army Camp (from the **Necropolis** series) 1997
Gelatin silver print
49 ¼ x 49 ¼ in. (125 x 125 cm)

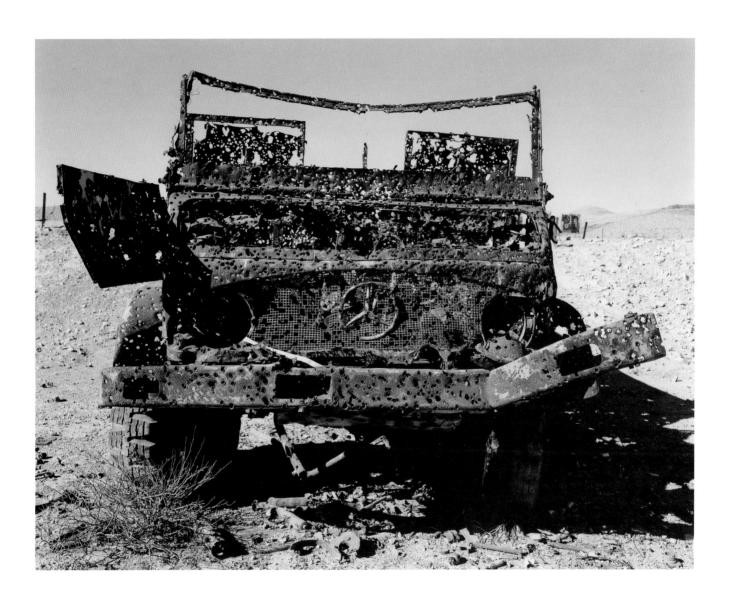

PLATE 17
GILAD OPHIR
From the **Necropolis** series 1996
Gelatin silver print
49 ½ x 56 in. (125.7 x 142.2 cm)

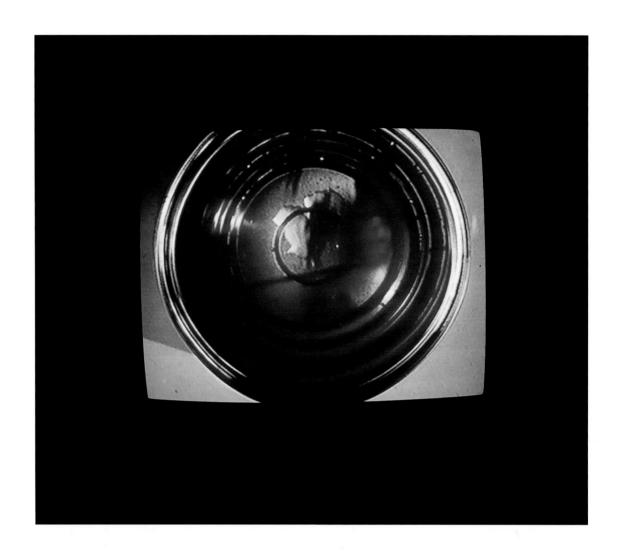

PLATE 18
MOSHE NINIO
Orange: Kythira 1996
Video
7 minutes

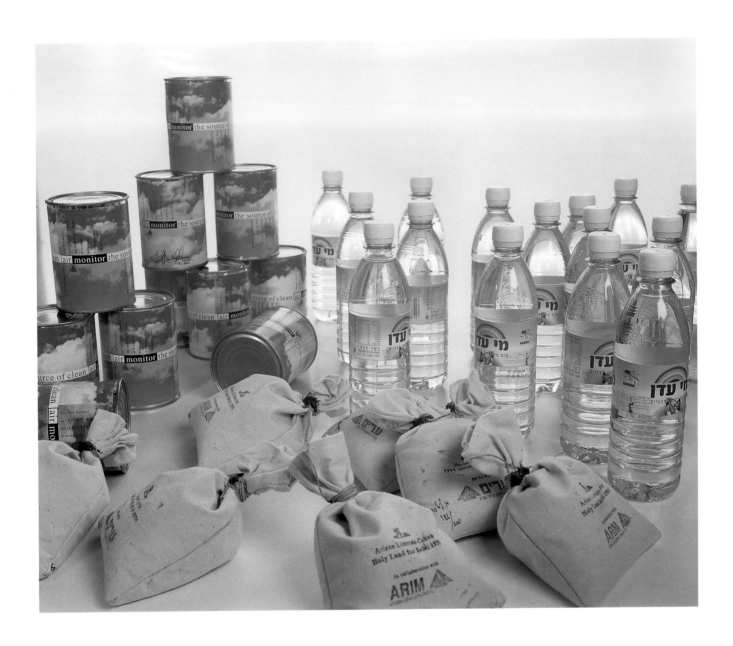

PLATE 19

ARIANE LITTMAN-COHEN

Holy Land for Sale, Holy Air, and **Holy Water**

from **Pro visions** 1998

Soil, air, water, paper, linen string, tin,
wax, and plastic

Holy Land for Sale 1996
each 5 ½ x 7 ½ in. (14 x 19 cm)

Holy Air 1996
each 4 ½ x 3 ⅜ in. diameter (11.5 x 8.5 cm)

Holy Water 1998
each 8 ⅝ x 2 ⅜ in. diameter (22 x 6 cm)

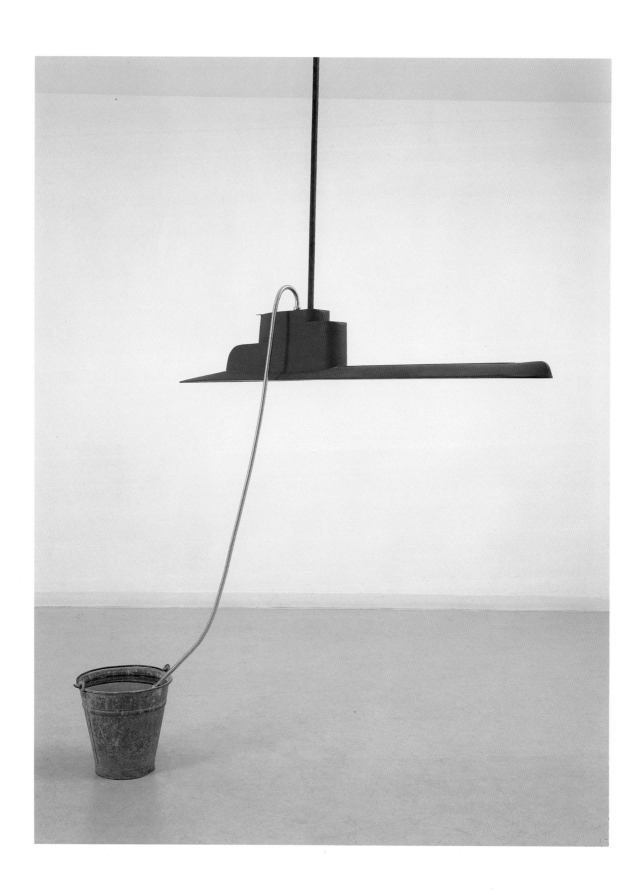

PLATE 20
ZVIKA KANTOR
Big Fishes Eat Small Fishes 1996
Wood, tubing, and bucket
6 x 61 x 8 ¼ in. (15 x 155 x 21 cm)

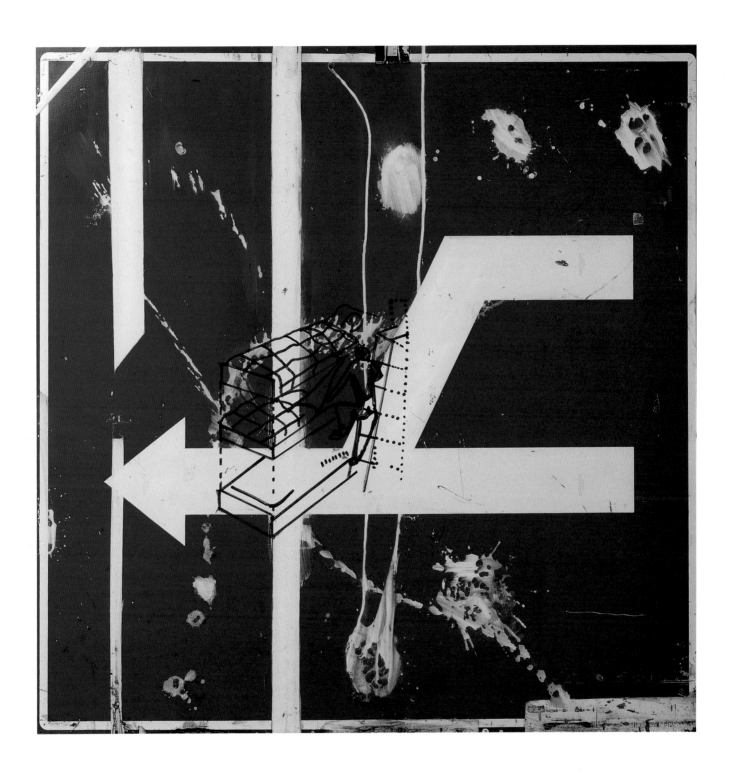

PLATE 21
IDO BAR-EL
Untitled 1994
Mixed media on aluminum street sign
31 ½ x 31 ½ in. (80 x 80 cm)

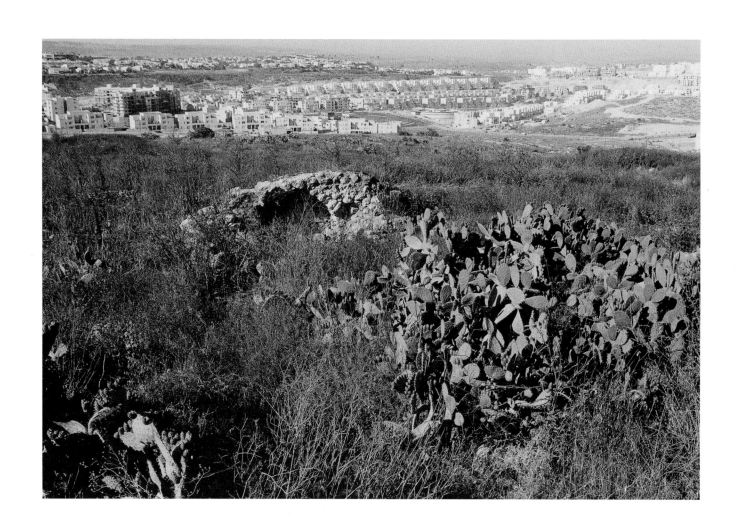

PLATE 22
SIMCHA SHIRMAN
City's Border, Mody'in 1997
Photograph from group of thirteen
Each 11 ⅞ x 15 ¾ in. (30 x 40 cm)

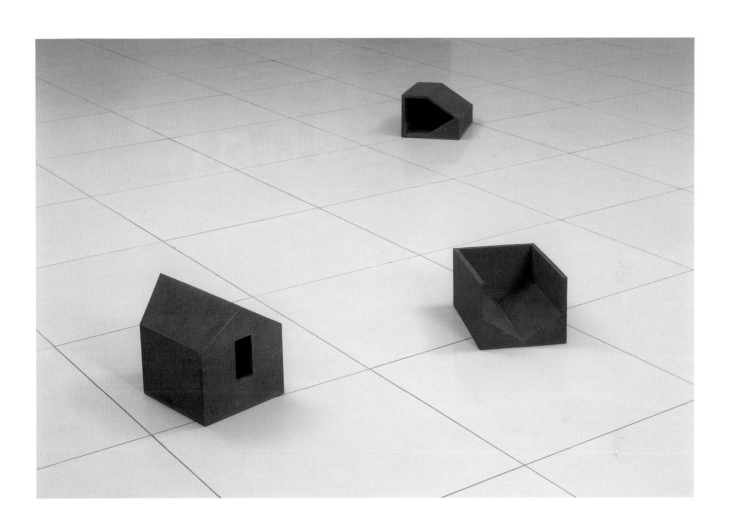

PLATE 23
MICHA ULLMAN
Day, Havdalah, and **Midnight** from the **Containers** series 1993
Iron plates and sand
Day: 6 ⅞ x 9 ½ x 12 ½ in. (17.5 x 24 x 32 cm)
Havdalah: 6 ⅞ x 12 ½ x 9 ⅞ in (17.5 x 32 x 25 cm)
Midnight: 9 ⅞ x 9 ½ x 12 ½ in. (25 x 24 x 32 cm)

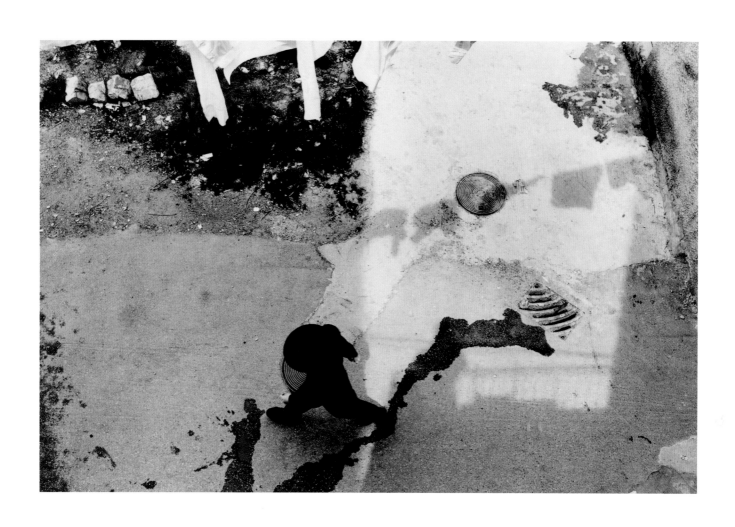

PLATE 24
PESI GIRSCH
Untitled 1997
Gelatin silver print
11 x 17 in. (27.9 x 43.2 cm)

PLATE 25
PAVEL WOLBERG
Untitled 1997
Color photograph
27 ½ x 39 ⅜ in. (70 x 100 cm)

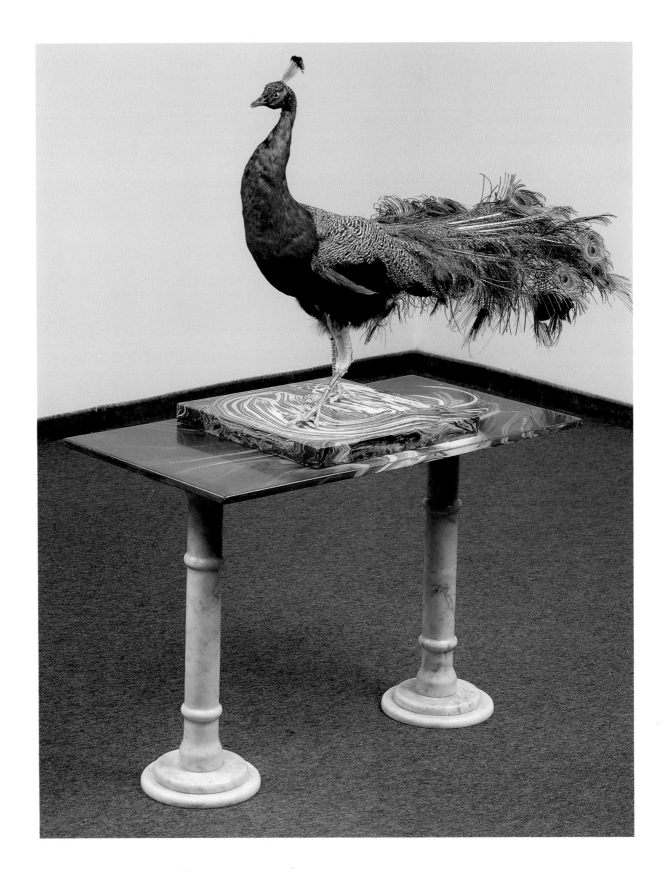

GIDEON GECHTMAN

Still Life no. 6, The Peacock 1994

Stuffed bird, marble, and artificial marble

Bird: 27 ½ x 43 ¼ x 15 ¾ in. (70 x 110 x 40 cm)

Table: 26 x 37 ⅜ x 20 in. (66 x 95 x 51 cm)

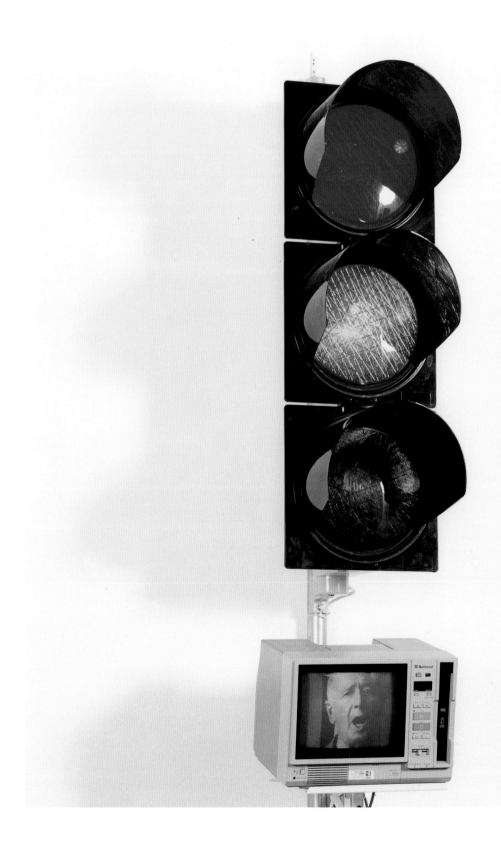

PLATE 27
BELU-SIMION FAINARU
Traffic Light to Heaven 1997
Traffic light, video, 14-inch television, and electric timer
59 x 15 ¾ x 15 ¾ in. (150 x 40 x 40 cm)

We contemplate aloud the associations of power, victimization, and the identification of the victim with the aggressor. His father was 12 when he had to survive on his own in the camp, or else perish. He so identified with the authoritative and and immaculate commander of the camp that he worked till he had an alternative set of clothing which he kept neat and clean for special wear.

Hannover, 1996

PLATE 28
JOEL KANTOR
Hannover 1996
Gelatin silver print
19 ¹¹⁄₁₆ x 23 ⅝ in. (50 x 60 cm)

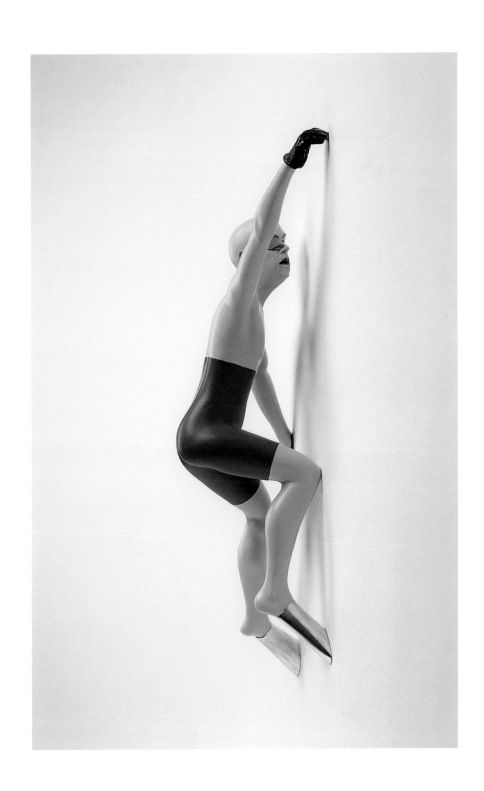

PLATE 29
URI KATZENSTEIN
Love Dub 1994–95
Oil on bronze
25 ⅝ in. high (65 cm)

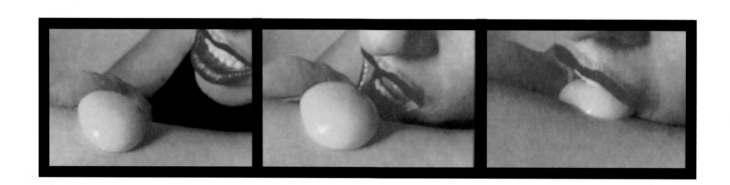

PLATE 31
MERILU LEVIN
Untitled 1994
Oil on board
19 ¹¹⁄₁₆ x 23 ⅝ in. (50 x 60 cm)

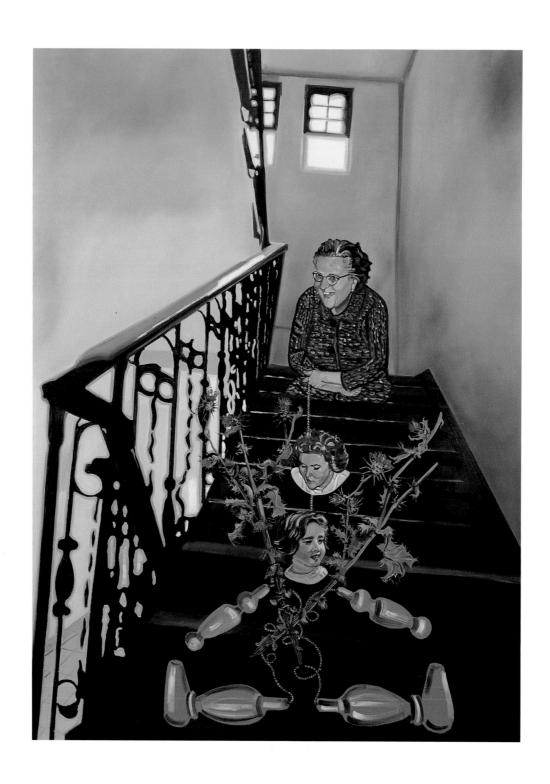

PLATE 32
NURIT DAVID
Buba and Thistle 1997
Oil on canvas
51 ⅛ x 37 ⅜ in. (130 x 95 cm)

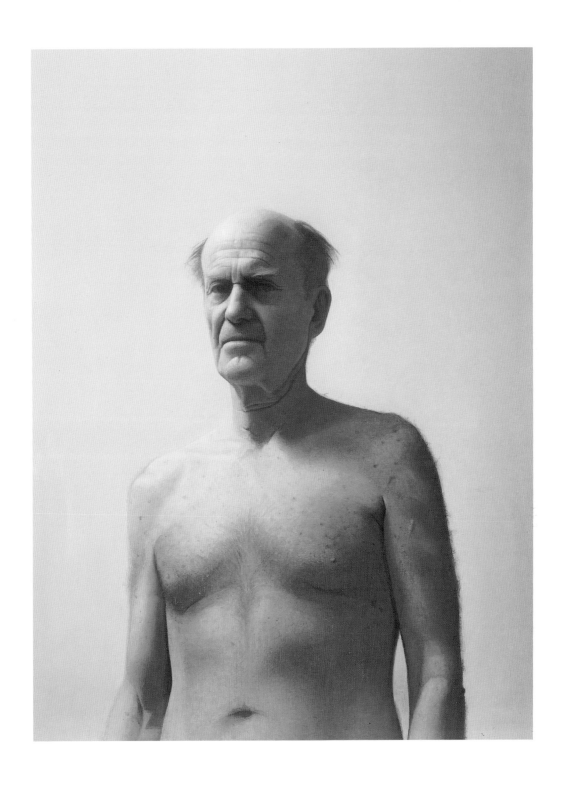

PLATE 33

ISRAEL HERSHBERG

Stern 1995

Oil on canvas, mounted on wood

25 ⅛ x 19 in. (64 .4 x 48.3 cm)

PLATE 34
TAL MATZLIAH
Decoration for Shavuot 1998
Oil and paper on board
19 ¹¹⁄₁₆ x 27 ⁹⁄₁₆ in. (50 x 70 cm)

PLATE 35
IBRAHIM NUBANI
Untitled 1994
Acrylic on canvas
47 ¼ x 47 ¼ in (120 x 120 cm)

The Artists

Aya

Gal

AYA & GAL

AYA
- Born in 1967, Jerusalem
- Lives in Jerusalem

Education
1989–93
- B.F.A., Bezalel
 Academy of Art and
 Design, Jerusalem

GAL
- Born in 1966, Haifa
- Lives in Jerusalem

Education
1988–90
- Bezalel Academy of Art
 and Design, Jerusalem

Solo Exhibitions
1993
- *Communication Project
 Between 2*, performance in
 various locations in Israel
1994
- Bograshov Gallery, Tel Aviv
1995
- *Naturalize/Soft Camera*
 Herzliya Museum of Art,
 Herzliya, Israel

1996
- *Marks: Artists Work
 Throughout Jerusalem*
 YMCA Tower, Jerusalem
- *Naturalize/0.7*
 The Teddy Kollek Stadium,
 Jerusalem
1998
- *Contemporary Artist Project:
 Aya & Gal Middle East
 Neturalize\100m*
 The Jewish Museum,
 New York

Group Exhibitions
1993
- *Antipathos: Black Humor,
 Irony, and Cynicism in
 Contemporary Israeli Art*
 The Israel Museum,
 Jerusalem
1994
- *Bograshov 3: The Suitcase*
 Bograshov Gallery, Tel Aviv
- *Me Yemalel Gvurot Israel*
 Bograshov Gallery, Tel Aviv
- *TA ASYA: Artificial Space
 in Given Time for Artistic
 Activity*
 Artists' Studio, Tel Aviv
- *90>70>90*
 Helena Rubinstein Pavilion
 for Contemporary Art,
 Tel Aviv Museum of Art

- *Tel Hai '94*
 Contemporary Art
 Meeting, Tel Hai, Israel
- *Terminal*
 Bograshov Gallery, Tel Aviv
- *Bograshov: The Street
 Export Surplus*
 Bograshov Gallery, Tel Aviv
- *Petrol Station "Paz"*
 Tel Aviv, Jerusalem, and
 Eilat
1996
- *Marks: Artists' Works
 Throughout Jerusalem*
 The Israel Museum,
 Jerusalem
1997
- Documenta X
 Kassel, Germany
- *Out of Senses*
 MUHKA, Museum of
 Modern Art, Antwerp,
 Belgium

Ido Bar-El

IDO BAR-EL

- Born in 1959, Tel Aviv
- Lives in Tel Aviv

Education
1980–84
- Bezalel Academy of Art and Design, Jerusalem

Awards
1984
- E. Elhani Prize, Fine Arts Department, Bezalel Academy of Art and Design, Jerusalem
1987
- Beatrice S. Kolliner Prize for a Young Artist, The Israel Museum, Jerusalem
1988
- Young Artist Prize, Israel Ministry of Education and Culture
1993
- Haddassa and Raphael Klachkin Award for Excellence in the Plastic Arts, America-Israel Cultural Foundation, Tel Aviv

Solo Exhibitions
1987
- Art Department Gallery, Bezalel Academy of Art and Design, Jerusalem
- *Israeli Art: Special Exhibition* The Israel Museum, Jerusalem
- Artists' Studio, Tel Aviv
1988
- *Tongue in Cheek* Givon Art Gallery, Tel Aviv
1989
- Art Department Gallery, Oranim, Israel
1991
- Kibbutz Cabri Gallery, Western Galilee, Israel
- Galerie Atelier Asperger, Berlin
1993
- Museum of Contemporary Art, Ghent, Belgium
- Tel Aviv Museum of Art
- Givon Art Gallery, Tel Aviv
1995
- *Street Signs and Other Works* Givon Art Gallery, Tel Aviv

Selected Group Exhibitions
1990
- *More Than Drawing* Givon Art Gallery, Tel Aviv
- *Toward the '90s* Mishkan Le'Omanut, Museum of Art, Ein Harod, Israel
1991
- *Israeli Art Now: An Extensive Presentation* Tel Aviv Museum of Art
- *Combined Painting* Givon Art Gallery, Tel Aviv
- *Routes of Wandering: Nomadism, Voyages and Transitions in Contemporary Israeli Art* The Israel Museum, Jerusalem
1992
- *Positionen Israel* Künstlerhaus Bethanien, Berlin
1993
- *In Extensio: Recent Acquisitions* Museum of Contemporary Art, Ghent, Belgium
- *Makom: Contemporary Art from Israel* Museum of Modern Art, Vienna
- *Ghent Was Invited, Jan Hoet's Choice* De Beyerd, Breda, Netherlands
1994
- *Halal: Contemporary Art from Israel* Sala Uno, Rome
- *Art . . . Language* Kunstwerke, Berlin
- *Black Holes: The White Locus* The 22nd Biennial, São Paulo, Brazil; traveled to the Haifa Museum of Modern Art
- *Emphasis* The Israel Museum, Jerusalem
- *Home-Works* Art Focus '94, Herzliya Museum of Art, Herzliya, Israel; Art Gallery, Haifa University; traveled to The Yavne Art Gallery, Yavne, Israel; Arad Museum, Arad, Israel
1995
- *The British, Israeli, and Argentinian Presentations from the 22nd Biennial of São Paulo* Centro Cultural Recoleta, Buenos Aires, Argentina
- *From the Rita and Arturo Schwarz Collection of Israel Art* The Israel Museum, Jerusalem
- *And the Verdict Is* Jack Schainman Gallery, New York
1996
- *Ketav: Flesh and Word in Israeli Art* Ackland Art Museum, The University of North Carolina, Chapel Hill
1998
- *The Lesser Light: Images of Illumination in Contemporary Israeli Art* The Israel Museum, Jerusalem

Avner Ben-Gal

AVNER BEN-GAL

- Born in 1966, Ashkelon, Israel
- Lives in Jaffa, Israel

Education
1989–93
- Bezalel Academy of Art and Design, Jerusalem

Awards
1993
- Marie Fisher Memorial Prize for the Advancement of Young Artists, Bezalel Academy of Art and Design, Jerusalem
1995
- Beatrice S. Kolliner Prize for a Young Artist, The Israel Museum, Jerusalem

Solo Exhibitions
1995
- *Avivit* Billy Rose Pavilion, The Israel Museum, Jerusalem
1997
- *Design* Beit Berl, Kfar Saba, Israel

1998
- *Curly Drugs* Sadnaot Haomanim, Tel Aviv

Group Exhibitions
1994
- *Installation* The Museum of Israeli Art, Ramat Gan, Israel
- *En-Suite* Contemporary Art Museum, Ghent, Belgium
- *Transit* Art Focus, New Central Station, Tel Aviv
1996
- *Thalidomide Years* Haifa Museum of Modern Art
1998
- *Video Plan No. 3* Herzliya Museum, Herzliya, Israel
- *The Lesser Light: Images of Illumination in Contemporary Israeli Art* The Israel Museum, Jerusalem

Pinchas Cohen Gan

PINCHAS COHEN GAN

- Born in 1942, Meknes, Morocco
- Immigrated to Israel in 1949
- Lives in Tel Aviv

Education
1970
- B.F.A., Bezalel Academy of Art and Design, Jerusalem
1971
- Central School of Art, London
1973
- B.A., Hebrew University, Jerusalem
1977
- M.F.A., School of the Arts, Columbia University, New York

Teaching Positions
1971–93
- Bezalel Academy of Art and Design, Jerusalem
1985
- Camera Obscura School of Art and Meimad Visual Art School, Tel Aviv
1988
- Parsons School of Design, New York

1989
- Beit Berl College for Art Teachers, Ramat Hasharon, Israel
1990
- Professor, Bezalel Academy of Art and Design, Jerusalem
1993–
- The Kalisher School of Art, Tel Aviv

Awards
1970
- Struck Prize, Bezalel Academy of Art and Design, Jerusalem
1972
- Aika Brown Prize for Young Artists, The Israel Museum, Jerusalem
1978
- Isaac Stern Creation Prize, America-Israel Cultural Foundation, Tel Aviv
1979
- Sandberg Prize for Israeli Art, The Israel Museum, Jerusalem
1991
- Eugene Kolb Prize, Tel Aviv Museum of Art
1991–92
- Israel Ministry of Education and Culture Prize for the Visual Arts

Selected Solo Exhibitions
1993
- *A Religious Exhibition* Chelouche Gallery, Tel Aviv
1994
- Givon Art Gallery, Tel Aviv
- Haifa University Gallery

1996
- Givon Art Gallery, Tel Aviv
- *Figure, Form, Formula*
 Weatherspoon Art Gallery,
 Greensboro, North Carolina
 1996–97
- Haifa Museum of Art
 1997
- Givon Art Gallery, Tel Aviv

Selected Group Exhibitions
 1992
- *Postscripts: "End"
 Representations in
 Contemporary Israeli Art*
 The Genia Schreiber
 University Art Gallery,
 Tel Aviv University
- *Positionen Israel*
 Künstlerhaus Bethanien,
 Berlin
- *Imagewriting: The Verbal
 Component in Israeli Art
 Toward the '90s*
 Janco-Dada Museum,
 Ein Hod, Israel; traveled to
 Rehovot Art Gallery,
 M. Smilanski Center for
 Culture, Rehovot, Israel;
 Kfar Saba Municipal
 Gallery, Kfar Saba, Israel
 1993
- *The Second Dimension:
 Twentieth-Century
 Sculptors' Drawings from
 the Brooklyn Museum*
 Brooklyn Museum,
 New York
- *Traces of Action*
 Chelouche Gallery, Tel Aviv
- Farideh Cadot Gallery, Paris
- Basel Art Fair, Basel
 1994
- *90>70>90*
 Helena Rubinstein Pavilion
 for Contemporary Art,
 Tel Aviv Museum of Art

- *Memories of/for the Future*
 Sagacho Alternative
 Exhibition Space, Tokyo
- Artists' Studio, Tel Aviv
- *Anxiety,* Art Focus
 The Museum of Israeli Art,
 Ramat Gan, Israel
 1995
- *From the Rita and Arturo
 Schwarz Collection of
 Israel Art*
 The Israel Museum,
 Jerusalem
- *Upon One of the Mountains:
 Jerusalem in Israeli Art*
 Taipei Fine Art Museum,
 Taiwan; Kaohsiun Museum
 of Fine Arts, China
 1996
- *Shalom Haver to Rabin—
 Beyond the Sticker*
 Abu-Cabir Gallery, Tel Aviv
- *Desert Cliché: Israel Now—
 Local Images*
 Arad Museum, Arad, Israel;
 traveled to Mishkan
 Le'Omanut, Museum of
 Art, Ein Harod, Israel;
 Herzliya Museum of Art,
 Herzliya, Israel; Bass
 Museum of Art, Miami
 Beach, Florida; Grey Art
 Gallery and Study Center
 of New York University,
 New York
 1997
- Sculpture Biennial,
 Mishkan Le'Omanut,
 Museum of Art, Ein Harod,
 Israel
 1998
- *Tikkun: Perspectives on
 Israeli Art of the Seventies*
 Genia Schreiber Art Gallery,
 Tel Aviv University

- *Perspectives on Israeli Art
 of the Seventies: The Eyes of
 the Nation—Visual Art
 in a Country Without
 Boundaries*
 Tel Aviv Museum of Art
- *Out of Action: Between
 Performance and the Object,
 1949–79*
 Museum of Contemporary
 Art, Los Angeles
- *Bamot*—the building,
 destruction, and restoration
 of High Places (Israel
 1948–1998)*
 Vienna Jewish Museum,
 Austria
- *To the East: Orientalism
 in the Arts in Israel*
 The Israel Museum,
 Jerusalem

Nurit David

NURIT DAVID

- Born in 1952, Tel Aviv
- Lives in Tel Aviv

Education
1975–78
- College for Art Teachers, Ramat Hasharon, Israel

Teaching Positions
1986–
- Beit Berl College for Art Teachers, Ramat Hasharon, Israel

Awards
1989
- Israel Discount Bank Prize for an Israeli Artist
1991
- Israel Ministry of Education and Culture Prize for the Visual Arts
1996
- George and Janet Jaffin Award for Excellence in the Plastic Arts, America-Israel Cultural Foundation, Tel Aviv

Solo Exhibitions
1987
- Bograshov Gallery, Tel Aviv
- The Israel Museum, Jerusalem
1991
- Givon Art Gallery, Tel Aviv
1994
- Givon Art Gallery, Tel Aviv

Group Exhibitions
1991
- The 21st International São Paulo Biennial, Brazil; traveled to The Museum of Israeli Art, Ramat Gan, Israel
1992
- *Imagewriting: The Verbal Component in Israeli Art Toward the '90s* Janco-Dada Museum, Ein Hod, Israel; traveled to Rehovot Art Gallery, M. Smilanski Center for Culture, Rehovot, Israel; Kfar Saba Municipal Gallery, Kfar Saba, Israel
1993
- *Locus: Contemporary Art from Israel* Fisher Gallery, University of Southern California, Los Angeles
1994
- *Anxiety*, Art Focus The Museum of Israeli Art, Ramat Gan, Israel
1995
- *Eight in November* Tel Aviv Museum of Art
- *From the Rita and Arturo Schwarz Collection of Israeli Art* The Israel Museum, Jerusalem

Belu-Simion Fainaru

BELU-SIMION FAINARU

- Born in 1959, Bucharest, Romania
- Immigrated to Israel in 1959
- Lives in Haifa

Education
1980
- B.A., University of Haifa
1984
- M.F.A., University of Chicago

Awards
1985
- City of Haifa Art Award, Haifa Art Foundation
1986
- America-Israel Cultural Foundation Art Award
1986–87
- Italian Government Scholarship
1988
- America-Israel Cultural Foundation Art Award
1989
- Belgian Government Scholarship
1991
- Work Completion Prize, Israel Ministry of Education and Culture
1992
- First Prize, Sculpture Competition, Levi and Fortuna Askenazi Sculpture Garden, Tel Aviv University
1994
- City of Haifa Young Artist Prize
- Art Award, Klein Plastik, Hilden, Germany
- Nahum Gutman Prize for Painting and Sculpture, Tel Aviv

Selected Solo Exhibitions
1991
- *Elixir for Nomads* Hugo Minnen Gallery, Antwerp, Belgium
- *Babbuk Ba-Rosh* Sarah Levy Gallery, Tel Aviv
1992
- *The Heart Needs More Room to Breathe* The Museum of Israeli Art, Ramat Gan, Israel
- Noga Gallery of Contemporary Art, Tel Aviv
- Wunschik Gallery, Düsseldorf, Germany
- Ric Urmel Gallery, Ghent, Belgium
1994
- *Suite 1203* Gabriele Rivet, Hilton Hotel, Amsterdam
- Hugo Minnen Gallery, Antwerp, Belgium
- *Presentation of the Bride* Kunstverein Arnsberg, Arnsberg, Germany
1995
- *If the World Alef* Staten Gallery, The Hague, Netherlands

- *Footsteps*
 Gabriele Rivet,
 Cologne, Germany

Selected Group Exhibitions
1991
- Transit Gallery,
 Leuven, Belgium
- *The Presence of the Absent:*
 The Empty Chair in
 Israeli Art
 The Genia Schreiber
 Gallery, Tel Aviv University
- *Four Guests*
 Artists' Studio, Tel Aviv
- Noga Gallery of
 Contemporary Art, Tel Aviv
- *Rooms*
 Artists' Studio, Tel Aviv
- *Young Artists Prize*
 (exhibition), Tel Aviv
 Museum of Art
- *Routes of Wandering:*
 Nomadism, Voyages and
 Transitions in Israeli Art
 The Israel Museum,
 Jerusalem
1992
- *The Artist as a Channel*
 Art Gallery, University
 of Haifa
- *Time of Sculpture, Time*
 of Photography
 Borochov Gallery, Tel Aviv
- *Makom*
 National Museum of Art,
 Seoul, South Korea
- Documenta IX
 Kassel, Germany
- *Discover-Rediscover*
 Ric Urmel Gallery,
 Ghent, Belgium
- *Fluxus Virus*
 Temporary Museum,
 Kaufhof, Parkhaus and
 Kölnischer Kunstverein,
 Cologne, Germany

- Second Sculpture Biennial,
 Ein Hod, Israel
- *Private Level*
 Sara Konforti Gallery,
 Jaffa, Israel
- *Dreams Alef*
 Mary Fauzi Gallery,
 Jaffa, Israel
- *Sculpture as Theater*
 Janco-Dada Museum,
 Ein Hod, Israel; traveled to
 the Museum of Art,
 Bat Yam, Israel; Arad
 Museum, Arad, Israel
- *Always Upward*
 Sara Levi Gallery, Tel Aviv
1993
- *The Israeli Artists of*
 Documenta IX
 Art Gallery, University of
 Haifa
- *Israeli Proposal for Aperto*
 Artifact Gallery,
 Jaffa, Israel
- *There*
 The Israel Museum,
 Jerusalem
- *America*
 Universidad Federal de Juiz
 De Flora Art Gallery,
 Juiz de Flora, Brazil;
 traveled to Rio de Janeiro,
 Brazil; São Paulo, Brazil;
 Belo Horizonte, Brazil
- *Inbetween*
 XXV Venice Biennale,
 Venice, Italy
- *Antipathos: Black Humor,*
 Irony, and Cynicism in
 Contemporary Israeli Art
 The Israel Museum,
 Jerusalem
- *Matchbox Exhibition*
 Yavne Art Gallery, Yavne,
 Israel; traveled to Janco-
 Dada Museum, Ein Hod,
 Israel

- *Überleben*
 Bonner Kunstverein,
 Bonn, Germany
1994
- *Boxes*
 Gabriele Rivet,
 Cologne, Germany
- *Local Scene*
 Noga Gallery of
 Contemporary Art, Tel Aviv
- *Meihalim* [Containers]
 From The Israel Museum
 Collection,
 The Israel Museum,
 Jerusalem
- *In the Tracks of the Bauhaus*
 Haaretz Building, Tel Aviv
- *Klein Plastik Austellung*
 Hilden, Germany
- *Anxiety*, Art Focus
 The Museum of Israeli Art,
 Ramat Gan, Israel
- Third Sculpture Biennial,
 Ein Hod, Israel
- *Home-Works*
 Herzliya Museum of Art,
 Herzliya, Israel
- *Memories of the Future*
 Sagacho Alternative
 Exhibition Art Space, Tokyo
- *Art and Image*
 Staten Gallery, The Hague,
 Netherlands
1995
- *Five Years Before 2000*
 Herzliya Museum of Art,
 Herzliya, Israel; traveled
 to Haifa University
- *Inbetween*
 Kloster Kamp-Lintfort,
 Germany
- *Object/Object Dialogue*
 Between Art and Design
 Herzliya Museum of Art,
 Herzliya, Israel; traveled
 to the Museum of Art,
 Bat Yam, Israel

- *Home-Works*
 Art Gallery, University
 of Haifa; traveled to Yavne
 Art Gallery, Yavne, Israel;
 Arad Museum, Arad, Israel
- *From the Rita and Arturo*
 Schwarz Collection of
 Israel Art
 The Israel Museum,
 Jerusalem
1996
- *Fluxus Yesterday, Today,*
 and Tomorrow—Art
 Without Limits
 Smolny Cathedral,
 St. Petersburg; traveled to
 Artists' House, Moscow
- *Windows*
 The Israel Museum,
 Jerusalem
1998
- *The Lesser Light: Images*
 of Illumination in
 Contemporary Israeli Art
 The Israel Museum,
 Jerusalem
- *To the East: Orientalism in*
 the Arts in Israel
 The Israel Museum,
 Jerusalem

Barry Frydlender

BARRY FRYDLENDER

- Born in 1954, Tel Aviv
- Lives in Herzliya, Israel

Education
1976–80
- Tel Aviv University

Awards
1984
- Gérard Levy Prize,
 The Israel Museum,
 Jerusalem

- **Selected Solo Exhibitions**
 1985
- The Israel Museum,
 Jerusalem
 1987
- *Photographs 1982–87*
 Athens Photography Center,
 Athens, Greece

Selected Group Exhibitions
1991
- *Patterns of Jewish Life:
 Jewish Thought and Beliefs,
 Life and Work within the
 Cultures of the World*
 Martin Gropius-Bau,
 Berlin
- *New Acquisitions*
 Tel Aviv Museum of Art

- *Routes of Wandering:
 Nomadism, Voyages and
 Transitions in Contemporary
 Israeli Art*
 The Israel Museum,
 Jerusalem
 1994
- *Black Holes: The White
 Locus*
 22nd International
 Biennial, São Paulo, Brazil;
 traveled to the Haifa
 Museum of Modern Art
- *Art Focus*, The Israel
 Museum, Jerusalem
- *Anxiety*, Art Focus
 The Museum of Israeli Art,
 Ramat Gan
 1997
- *Eliach Shenit*
 Haifa Museum of Modern
 Art
- *Eternal Dialogue*
 Tower of David Museum,
 Jerusalem
- *Ainsi de Suite*
 Centre Regional d'Art
 Contemporain, Sète, France
 1998
- *Mad Media*
 Arad Museum, Arad, Israel
- *The Lesser Light: Images
 of Illumination in
 Contemporary Israeli Art*
 The Israel Museum,
 Jerusalem

Gideon Gechtman

GIDEON GECHTMAN

- Born in 1942, Alexandria,
 Egypt
- Immigrated to Palestine
 in 1945
- Lives in Rishon Le Zion,
 Israel

Education
1961–62
- Avni Art Institute, Tel Aviv
 1962–63
- Ealing School of Art,
 London
 1968–71
- Hammersmith College
 of Art, London
 1975–76
- Tel Aviv University

Teaching Positions
1972–75
- Lecturer, Bezalel Academy
 of Art and Design,
 Jerusalem
 1976–
- Beit Berl College for Art
 Teachers, Ramat Hasharon,
 Israel

Awards
1990
- Israel Ministry of Education
 and Culture Prize for the
 Visual Arts
 1990
- The Histadrut Prize for
 Painting and Sculpture,
 Israel
 1993
- Israel Ministry of Arts and
 Science Prize
 1995
- Israeli Artist Prize,
 Tel Aviv Museum of Art
 1997
- Israeli Artist Prize,
 Israel Discount Bank Prize,
 The Israel Museum,
 Jerusalem

Selected Solo Exhibitions
1992
- *Echo*
 Bograshov Gallery, Tel Aviv
 1996
- *Works*
 Chelouche Gallery, Tel Aviv

Selected Group Exhibitions
1990
- *Life Size*
 The Israel Museum,
 Jerusalem
 1991
- *Perspective*
 Tel Aviv Museum of Art
 1992
- The Second Biennial of
 Sculpture
 Ein Hod, Israel
 1993
- *Makom*
 Museum of Modern Art,
 Vienna

• *Antipathos: Black Humor, Irony, and Cynicism in Contemporary Israeli Art*
The Israel Museum, Jerusalem

1994
• *Burnt/Whole*
W. P. A., Washington D.C.; traveled to Institute of Contemporary Art, Boston, Massachusetts
• *Friends*
Art Focus
Haifa Museum of Modern Art

1997
• *Fantasy*
Herzliya Museum of Art, Herzliya, Israel
• *Another Language*
Haifa Museum of Modern Art

1998
• *International Passage*
Chelouche Gallery, Tel Aviv
• *Out of Action: Between Performance and the Object, 1949–79*
The Museum of Contemporary Art, Los Angeles
• *Tikkun: Perspectives on Israeli Art of the Seventies*
Genia Schreiber Art Gallery, Tel Aviv University
• *Perspectives on Israeli Art of the Seventies: The Eyes of the Nation—Visual Art in a Country Without Boundaries*
Tel Aviv Museum of Art
• *The Lesser Light: Images of Illumination in Contemporary Israeli Art*
The Israel Museum, Jerusalem

Moshe Gershuni

MOSHE GERSHUNI

• Born in 1936, Tel Aviv
• Lives in Tel Aviv

Education
1960–64
• Avni Art Institute, Tel Aviv

Teaching Positions
1972–77
• Bezalel Academy of Art and Design, Jerusalem
1978–
• Beit Berl College for Art Teachers, Ramat Hasharon, Israel

Awards
1969
• Aika Brown Prize, The Israel Museum, Jerusalem
1982
• Sandberg Prize for Israeli Art, The Israel Museum, Jerusalem
1988
• Israel Ministry of Education and Culture Prize for the Visual Arts

Selected Solo Exhibitions
1990
• *Moshe Gershuni: Works 1987–1990*
Tel Aviv Museum of Art
1993
• *Moshe Gershuni: Prints 1992–93*
The Museum of Israeli Art, Ramat Gan, Israel
1997
• *Moshe Gershuni: Prints 1996–97*
Jerusalem Print Workshop

Selected Group Exhibitions
1991
• *Israeli Art Around 1990*
Städtische Kunsthalle, Düsseldorf, Germany; traveled to Artists' House, Moscow; The Israel Museum, Jerusalem
1992
• *Postscripts: "End" Representations in Contemporary Israeli Art*
The Genia Schreiber University Art Gallery, Tel Aviv University
• *Positionen Israel*
Künstlerhaus Bethanien, Berlin
• *Imagewriting: The Verbal Component in Israeli Art Toward the '90s*
Janco–Dada Museum, Ein Hod, Israel; traveled to Rehovot Art Gallery, M. Smilanski Center for Culture, Rehovot, Israel; Kfar Saba Municipal Gallery, Kfar Saba, Israel

1993
• *Mutual Feedback— Painting/Sculpture/Print*
Jerusalem Print Workshop, Florence Miller Art Center, Jerusalem
• *From the Inside Out: Eight Contemporary Artists*
The Jewish Museum, New York

1994
• *Along New Lines: Israeli Drawings Today*
The Israel Museum, Jerusalem
• *Anxiety*, Art Focus
The Museum of Israeli Art, Ramat Gan, Israel

1996
• *Long Memory/Short Memory*
The City Gallery of Contemporary Art, Raleigh, North Carolina

1997
• *Book Obsession*
Tel Aviv Museum of Art

1998
• *Bamot*—the building, destruction, and restoration of High Places (Israel 1948–1998)*
Vienna Jewish Museum, Austria
• *To the East: Orientalism in the Arts in Israel*
The Israel Museum, Jerusalem
• *The Lesser Light: Images of Illumination in Contemporary Israeli Art*
The Israel Museum, Jerusalem

Pesi Girsch

PESI GIRSCH

- Born in 1954, Munich, Germany
- Immigrated to Israel in 1968
- Lives in Tel Aviv

Education
1969–74
- Studied sculpture with Rudi Lehmann, Givatayim, Israel
1972–74
- Studied drawing with Professor Joseph Schwartzman, Tel Aviv
1974–77
- Akademie der Bildenden Künste, Munich, Germany
1982–87
- College for Art Teachers Ramat Hasharon, Israel

Awards
1988
- America-Israel Cultural Foundation Art Award
1989
- Gérard Levy Award, The Israel Museum, Jerusalem
- Young Artist Prize, Israel Ministry of Education and Culture
- America-Israel Cultural Foundation Scholarship, Tel Aviv

1996
- Scholarship of the DAAD (German Academic Artists Exchange Service), Berlin

Selected Solo Exhibitions
1989
- Photography Department Gallery, Beit Berl College for Art Teachers, Ramat Hasharon, Israel
1992
- *The Aura of the Photographed* The Israel Museum, Jerusalem
- Municipal Gallery, Kfar Saba, Israel

Selected Group Exhibitions
1991
- *Sight and Vision* The Israel Museum, Jerusalem
1992
- *Patterns of Jewish Life: Jewish Thought and Beliefs, Life and Work within the Culture of the World* Martin Gropius-Bau, Berlin, Germany
1993
- *The Range of Realism* Tel Aviv Museum of Art
1994
- *Through the Lattice* Art Focus Tower of David Museum of the History of Jerusalem
- *Photography between Documentary & Art* Art Focus Municipal Gallery, Kfar Saba, Israel
1995
- *Critic's Choice* Artists' Studio, Tel Aviv

- *Artists of the Art Department* Haifa University Art Gallery
- *Contemporary Israeli Photography* Tiroche Auction House, Tel Aviv
- Ilana Goor Museum, Jaffa, Israel
- *The Other Side of Beauty* Rheinisches Landesmuseum, Bonn
- *November Salon* Contemporary Art at Dafna Naor Gallery, Jerusalem
1996
- *Outdoor Museum* The Art Museums Forum, Arad, Israel; traveled to Kfar Saba, Israel, and Rehovot, Israel
1997
- *Documentation or Fiction* Photography Department Gallery, Bezalel Academy of Art and Design, Jerusalem
- *Art in the University, Teachers and Graduates of the Art Department* Haifa University
- *Love from First Sight, Dafna Naor's Collection* Kibbutz Cabri Gallery, Western Galilee, Israel
1998
- *Condition Report* The Israel Museum, Jerusalem
- *The Child of the Photographer* New Art Workshop, Ramat Eliyahu, Israel
- *Female Artists in Israeli Art—Five Decades* Haifa Museum of Modern Art

Israel Hershberg

ISRAEL HERSHBERG

- Born in 1948, Displaced Persons Camp, Linz, Austria
- Immigrated to Israel in 1949
- Moved to the United States in 1958
- Returned to Israel in 1984
- Lives in Jerusalem

Education
1966–68
- Attended Brooklyn Museum School, Brooklyn, New York
1972
- B.F.A., Pratt Institute, Brooklyn, New York
1973
- M.F.A., State University of New York, Albany

Teaching Positions
1973–84
- Instructor of painting and drawing at the Maryland Institute College of Art, Baltimore
1983–84
- Instructor of painting, New York Academy of Art, New York

Awards
1991
• Sandberg Prize for Israeli
Art,
The Israel Museum,
Jerusalem

Selected Solo Exhibitions
1997
• Marlborough Gallery,
New York
1998
• The Israel Museum,
Jerusalem

Selected Group Exhibitions
1990
• *The Art of Describing:*
Homage and Appropriation
The Israel Museum,
Jerusalem
• *Toward the '90s*
Mishkan Le'Omanut,
Museum of Art, Ein Harod,
Israel
• *Connections*
The Israel Museum,
Jerusalem
• *Israeli Art Around 1990*
Städtische Kunsthalle,
Düsseldorf, Germany;
traveled to Artists' House,
Moscow; The Israel
Museum, Jerusalem
1991
• *Israeli Art Now:*
An Extensive Presentation
Tel Aviv Museum of Art
1992–93
• *Painting the Seen*
The Israel Museum,
Jerusalem
1994
• *Art Focus: Contemporary*
Israeli Art Facing Reality
Mishkenot Sha'ananim,
Jerusalem

1996
• *Four Realist Painters*
Reuben & Edith Hecht
Museum, University of
Haifa
1997
• *Portraits*
Tel Aviv Museum of Art

Nir Hod

NIR HOD

• Born in 1970, Tel Aviv
• Lives in Tel Aviv

Education
1989–93
• Bezalel Academy of Art
and Design, Jerusalem
1991
• Cooper Union Academy
of Art, New York

Solo Exhibitions
1997
• The Museum of Israeli Art,
Ramat Gan, Israel
1998
• *Forever*
LiebmanMagnan, New York

Selected Group Exhibitions
1993
• *Antipathos: Black Humor,*
Irony, and Cynicism in
Contemporary Israeli Art
The Israel Museum,
Jerusalem
1994
• *Meta-Sex '94: Identity,*
Body, and Sexuality
Mishkan Le'Omanut
Museum of Art, Ein Harod,
Israel; traveled to
Museum of Art, Bat Yam,
Israel

• *Transit*
Alternative Space at the
Central Bus Station,
Tel Aviv
• *Lick My Varnish*
Names Night Club, Tel Aviv
1995
• Beit Ha'amudim, Tel Aviv
• *In Construction*
Haifa Museum of Modern
Art
• Noga Gallery of
Contemporary Art, Tel Aviv
• *Windows*
The Israel Museum,
Jerusalem
1996
• *Desert Cliché: Israel Now—*
Local Images
Arad Museum, Arad, Israel;
traveled to Mishkan
Le'Omanut, Museum
of Art, Ein Harod; Herzliya
Museum of Art, Herzliya,
Israel; Bass Museum of Art,
Miami Beach, Florida; Grey
Art Gallery and Study
Center of New York
University, New York
1997
• *Fantasia*
Herzliya Museum of Art,
Herzliya, Israel
1998
• *Bamot*—the building,*
destruction, and restoration
of High Places (Israel
1948–1998)
Vienna Jewish Museum,
Austria
• *Condition Report*
The Israel Museum,
Jerusalem
• *The Lesser Light: Images*
of Illumination in
Contemporary Israeli Art
The Israel Museum,
Jerusalem

Joel Kantor

JOEL KANTOR

- Born in 1948, Montreal, Canada
- Immigrated to Israel in 1976
- Lives in Tel Aviv

Education
1973
- J.D., McGill University, Montreal

1980–82
- Hadassah Community College, Jerusalem

Teaching Position
1996–
- Bezalel Academy of Art and Design, Jerusalem

Awards
1986
- Gérard Levy Award, The Israel Museum, Jerusalem

Selected Solo Exhibitions
1996
- Camera Obscura, Tel Aviv
1998
- Jewish Historical Museum, Amsterdam

Group Exhibitions
1992
- B'nai Brith Klutznick Museum, Washington, D.C.
1996
- Mary Fauzi Gallery, Jaffa, Israel
1998
- *Condition Report* The Israel Museum, Jerusalem
- *Erotica Palestina* Ami Steinitz Gallery, Tel Aviv
- *Capturing Reality: 19 Israeli and Palestinian Photographers* Tennessee State Museum, Nashville, Tennessee
- *To the East: Orientalism in the Arts in Israel* The Israel Museum, Jerusalem

Zvika Kantor

ZVIKA KANTOR

- Born in 1955, Tel Aviv
- Lives in Tel Aviv

Education
1978–80
- College for Art Teachers Ramat Hasharon, Israel
1981–85
- Academy of Arts, Hamburg Germany

Awards
1980–81
- America-Israel Cultural Foundation Scholarship, Tel Aviv
1981
- Scholarship for Art Study at the Academy of Fine Arts, Florence, Italy
1987
- Altonaer Art Prize Hamburg
1992
- Beatrice S. Kolliner Prize for a Young Artist The Israel Museum, Jerusalem
1995
- Israel Ministry of Arts and Science Prize

Solo Exhibitions
1990
- *The Allegory of the Stick and Desire* Art Studio Gallery, Yavne, Israel
1991
- *The Sorrow of the World Dressed Up as Pineapple Fragrance* Städtische Galerie, Hällisch-Frankisches Museum, Schwäbisch Hall, Germany
1992
- *Packages of Feeling* The Museum of Israeli Art, Ramat Gan, Israel
1993
- *Snow White and the Seven Deadly Sins* Jans Gallery, Hamburg
1996
- *Objects from the Third Zone* Colonnade House, Tel Aviv

Selected Group Exhibitions
1990
- *Toward the '90s* Mishkan Le'Omanut, Museum of Art, Ein Harod, Israel
1993
- *Made in Hamburg* Künstlerhaus, Hamburg
- *Antipathos: Black Humor, Irony, and Cynicism in Contemporary Israeli Art* The Israel Museum, Jerusalem
1994
- *We Must Be Happy* Art Museum, Dessau, Germany

• *Anxiety,* Art Focus
The Museum of Israeli Art,
Ramat Gan, Israel
1994–95
• *Home-Works*
Art Focus
Herzliya Museum of Art;
Herzliya, Israel; traveled
to Art Gallery, Haifa
University; The Yavne Art
Gallery, Yavne, Israel; Arad
Museum, Arad, Israel
1995
• *From the Rita and Arturo
Schwarz Collection of
Israel Art*
The Israel Museum,
Jerusalem

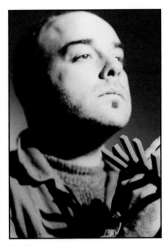
Uri Katzenstein

URI KATZENSTEIN

• Born in 1951, Tel Aviv
• Lives in Tel Aviv

Education
1971–72
• Avni Institute, Tel Aviv
1974–76
• Indiana University,
Bloomington, Indiana
1978–79
• San Francisco Art Institute,
San Francisco

Teaching Positions
1990–
• Beit Berl College for Art
Teachers, Ramat Hasharon
• Camera Obscura, Tel Aviv

Awards
1982
• Work Encouragement
Award,
The Kitchen, New York
1989
• Israel Ministry of Education
and Culture Prize for the
Visual Arts
1992
• George and Janet Jaffin
Award for Excellence in the
Plastic Arts,
America-Israel Cultural
Foundation, Tel Aviv

Solo Exhibitions
1987
Dvir Gallery, Tel Aviv

Group Exhibitions
1990
• *Ein Hod Sculpture Biennial*
Ein Hod, Israel
• Artists' Studio, Tel Aviv
1991
• *Israeli Art Around 1990*
Städtische Kunsthalle,
Düsseldorf, Germany;
traveled to Artists' House,
Moscow; The Israel
Museum, Jerusalem
• *Israeli Art Now—An
Extensive Presentation*
Tel Aviv Museum of Art
• 21st International Biennial
of São Paulo, Brazil;
traveled to The Museum of
Israeli Art,
Ramat Gan, Israel
• Chelouche Gallery, Tel Aviv
1992
• *Postscripts:
"End" Representations in
Contemporary Israeli Art*
The Genia Schreiber
University Art Gallery,
Tel Aviv University
• *Design Line Art*
The Museum of Israeli Art,
Ramat Gan, Israel
• *Who Is Signed on the Duck?*
Bograshov Gallery, Tel Aviv
1993
• *Makom—Contemporary Art
from Israel*
Museum of Modern Art,
Stiftung Ludwig, Vienna
• *Missive*
The Israel Museum,
Jerusalem

• *Antipathos: Black Humor,
Irony, and Cynicism in
Contemporary Israeli Art*
The Israel Museum,
Jerusalem
1994
• *Anxiety,* Art Focus
The Museum of Israeli Art,
Ramat Gan, Israel

Roi Kuper

ROI KUPER

•Born in 1956, Kibbutz
 Mephalsim, Israel
•Lives in Tel Aviv

Education
 1980–82
•Hadassah College,
 Jerusalem
 1983–84
•College for Art Teachers
 Ramat Hasharon, Israel

Teaching Positions
 1991–94
•Beit Berl College for Art
 Teachers, Ramat Hasharon,
 Israel
 1983–
•Department of
 Photography, Camera
 Obscura, Tel Aviv
 1994–
•Bezalel Academy of Art
 and Design, Jerusalem

Awards
 1992
•French Embassy Prize
 in Israel
 1995
•Gérard Levy Prize,
 The Israel Museum,
 Jerusalem

Selected Solo Exhibitions
 1990
•Dizengoff Center Gallery,
 Tel Aviv
 1991
•Borochov Gallery, Tel Aviv
•Camera Obscura Gallery,
 Tel Aviv
 1994
•Camera Obscura Gallery,
 Tel Aviv
 1995
•Beit Ha'amudim, Tel Aviv
 1996
•Borochov Gallery, Tel Aviv
 (project with Gilad Ophir)
•The Israel Museum,
 Jerusalem (project with
 Gilad Ophir)
 1997
•Limbus Gallery, Tel Aviv
 1998
•Noga Gallery of
 Contemporary Art
 Tel Aviv (project with Gilad
 Ophir)

Group Exhibitions
 1991
•*One City, Five O'clock in
 the Afternoon*
 Suzanne Dallal Center,
 Tel Aviv
 1992
•*New Directions in Israeli
 Photography*
 Artists' House, Jerusalem
•*Curators*
 Sara Konforti Gallery,
 Jaffa, Israel
 1993
•*The Range of Realism*
 Tel Aviv Museum of Art
 1994
•Borochov Gallery at
 Camera Obscura, Tel Aviv
•Camera Obscura Gallery,
 Tel Aviv

•*Contemporary Photography
 in Israel*
 The Israel Museum,
 Jerusalem
•*90>70>90*
 Tel Aviv Museum of Art
 1997
•*Details Without Trail*
 Beit Ha'am Gallery, Tel Aviv
 1998
•*Bamot*—the building,
 destruction, and restoration
 of High Places (Israel
 1948–1998)*
 Vienna Jewish Museum,
 Austria
•*Quo Vadis*
 Artists' House, Jcrusalem
•*Condition Report*
 The Israel Museum,
 Jerusalem

Moshe Kupferman

MOSHE
KUPFERMAN

•Born in 1926, Jaroslav,
 Poland
•Immigrated to Israel
 in 1948
•Lives on Kibbutz Lohamei
 Hagetaot, Israel

Education
 1950–52
•Studied painting with
 E. Friedlaender, Haifa
 1953
•Studied painting with
 Haim Atar, Ein Harod,
 Israel; with Yosef Zaritsky
 and Avigdor Stematsky,
 Kibbutz Na'an, Israel

Selected Solo Exhibitions
 1993
•Museum Sztuki, Lodz
 Centrum Sztuki
 Wspólczesnej, Warsaw
 1994
•Studio Bocchi, Rome
•*Artist—Messenger of Peace*
 Eretz Israel Museum,
 Tel Aviv
 1995
•Shigeru Yokete, Tokyo
 1997
•Shigeru Yokete, Tokyo

1998
· *Moshe Kupferman: Paintings, Works on Paper, and Scrolls*
Goldie Paley Gallery, Moore College of Art and Design, Philadelphia

Selected Group Exhibitions
1991
· *Art in Israel Today*
Detroit Institute of Arts
· *Contemporary Art in Israel*
Gulbenkian Foundation, Lisbon
1992
· *Beyond Logos*
Museum of Modern Art, Belgrade
· *Positionen Israel*
Künstlerhaus Bethanien, Berlin
1994
· *Along New Lines— Israeli Drawing Today*
The Israel Museum, Jerusalem
· *Emphasis*
The Israel Museum, Jerusalem
· *Anxiety,* Art Focus
The Museum of Israeli Art, Ramat Gan, Israel
1995
· *Where Is Abel Thy Brother?*
National Gallery of Contemporary Art, Warsaw
· *From the Rita and Arturo Schwarz Collection of Israel Art*
The Israel Museum, Jerusalem
· *Carnegie International 1995*
Carnegie Museum of Art, Pittsburgh, Pennsylvania

1996
· *Long Memory/Short Memory*
City Gallery of Contemporary Art, Raleigh, North Carolina
1997
· *Book Obsession*
Tel Aviv Museum of Art
1998
· *Between Beauty and Destiny: Three Generations of Israeli Art*
Cleveland Center for Contemporary Art, Cleveland, Ohio

Raffi Lavie

RAFFI LAVIE

· Born in 1937, Tel Aviv
· Lives in Tel Aviv

Education
· State Art Teachers' Training College, Tel Aviv

Teaching Positions
1970s
· College for Art Teachers, Ramat Hasharon, Israel

Solo Exhibitions
1997
· *Paintings on Reproductions*
Givon Art Gallery, Tel Aviv
· *In Memory of Rabin*
Givon Art Gallery, Tel Aviv

Group Exhibitions
1992
· *Positionen Israel*
Künstlerhaus Bethanien, Berlin
· *Imagewriting: The Verbal Component in Israeli Art Toward the '90s*
Janco-Dada Museum, Ein Hod, Israel; traveled to Rehovot Art Gallery, M. Smilanski Center for Culture, Rehovot, Israel; Kfar Saba Municipal Gallery, Kfar Saba, Israel

1994
· *90>70>90*
Helena Rubinstein Pavilion for Contemporary Art, Tel Aviv Museum of Art
1995
· *Israeli Art at the Israeli Discount Bank*
Tel Aviv
1997
· *Opera d'arte in formato ridotto da israele*
Rome
1998
· *Perspectives on Israeli Art of the Seventies: The Eyes of the Nation—Visual Art in a Country Without Bounaries*
Tel Aviv Museum of Art
· *To the East: Orientalism in the Arts in Israel*
The Israel Museum, Jerusalem

Merilu Levin

MERILU LEVIN

- Born in 1967, Jerusalem
- Lives in Jerusalem

Education
1990–93
- Bezalel Academy of Art and Design, Jerusalem

Awards
1993
- Marie Fisher Memorial Prize for the Advancement of Young Artists, Fine Arts Department, Bezalel Academy of Art and Design, Jerusalem
1995
- Oscar Hendler Award
1996
- Young Artist Prize, Israel Ministry of Arts and Science
- America-Israel Cultural Foundation Scholarship, Tel Aviv
- Young Artist Award, Association of Painters and Sculptors, Tel Aviv
1997–98
- American-Israel Cultural Foundation Scholarship, Tel Aviv

Solo Exhibitions
1993
- *Hand Delivered*
 Borochov Gallery, Tel Aviv
1994
- *Doing Good*
 Noga Gallery of Contemporary Art, Tel Aviv
1995
- Gallery, Kibbutz Lohamei Hagetaot, Israel
1997
- *Foreplay*
 Noga Gallery of Contemporary Art, Tel Aviv

Group Exhibitions
1994
- *The Sign in Its Entirety*
 Borochov Gallery, Tel Aviv
- *Above Painting*
 The Museum of Israeli Art, Ramat Gan, Israel
- *Meta-Sex '94: Identity, Body and Sexuality*
 Mishkan Le'Omanut, Museum of Art, Ein Harod, Israel; traveled to the Museum of Art, Bat Yam, Israel
- *The Pleasure of Deceiving: Figurative Painting*
 Noga Gallery of Contemporary Art, Tel Aviv
1995
- *The Critics' Choice*
 Association of Painters and Sculptors, Tel Aviv
- *Autumn Salon*
 The Museum of Israeli Art, Ramat Gan, Israel
- *The Pleasure of Deceiving 2: Figurative Painting*
 Noga Gallery of Contemporary Art, Tel Aviv

1996
- *The Sign in Its Entirety 1, 2, 3*
 Ami Steinitz Gallery, Tel Aviv
- *Israeli Art from the 1920s to the Present*
 Tel Aviv Museum of Art
- *Femina Sapiens*
 Artists' House, Jerusalem
- *Art Focus*
 Noga Gallery of Contemporary Art, Tel Aviv
- *Nehama in the Nude*
 Nehama Gallery, Jaffa, Israel
1997
- *Truly*
 The Turkish Railway Station Gallery, Beersheva, Israel
- *Noga Gallery at Yavne*
 Yavne Gallery, Yavne, Israel
- *Object*
 Kibbutz Beeri Gallery, Beeri, Israel
- *Artschmockoos*
 Limbus Gallery, Tel Aviv
- *Ha'ir*
 Artists' House, Jerusalem
1998
- *Different Matter*
 Eretz Israel Museum, Tel Aviv
- *Retail Price*
 Pyramid Center of Contemporary Art, Haifa
- *Political Art of the '90s*
 Haifa Museum of Modern Art

Limbus Group

LIMBUS GROUP

JUDITH GUETTA

- Born in 1963, Jerusalem
- Lives in Tel Aviv

Education
1982–84
- Camera Obscura School of Art, Tel Aviv
1984–88
- B.F.A., Bezalel Academy of Art and Design, Jerusalem

GALIA GUR-ZEEV

- Born in 1954, Israel
- Lives in Tel Aviv

Education
1984–88
- B.F.A., Bezalel Academy of Art and Design, Jerusalem

DAFNA ICHILOV

- Born in 1964, Tel Aviv
- Lives in Tel Aviv

Education
1988
- B.F.A., Bezalel Academy of Art and Design, Jerusalem

Professional Activities
1992–
•Directors and Curators
Limbus Gallery, Tel Aviv

Limbus Group Awards
1990–91
•America-Israel Cultural
Foundation Scholarship,
Tel Aviv
1994
•Gérard Levy Prize,
The Israel Museum,
Jerusalem

Limbus Group Exhibitions
1992
•*Room-Space: One Exhibition
of Five*
Limbus Gallery, Tel Aviv
1994
•*Atlantis—One Exhibition
of Five, No. 2*
Limbus Gallery, Tel Aviv
1997
•*Embroideries of Generals*
The Arts Pavilion, Ramat
Hasharon, Israel; traveled
to the 2nd International
Photo Biennial, Tokyo
1998
•*Condition Report*
The Israel Museum,
Jerusalem
•*Bamot*—the building,
destruction, and restoration
of High Places (Israel
1948–1998)*
Vienna Jewish Museum,
Austria

Ariane Littman-Cohen

ARIANE
LITTMAN-COHEN

•Born in 1962, Lausanne,
Switzerland
•Immigrated to Israel
in 1981
•Lives in Jerusalem

Education
1986
•B.A., The Hebrew
University of Jerusalem
1991
•B.F.A., Bezalel Academy of
Art and Design, Jerusalem
1996
•M.F.A., Bezalel Academy of
Art and Design, Jerusalem,
and the Hebrew University
of Jerusalem

Professional Activities
1991–94
•Assistant Curator,
The Israel Museum,
Jerusalem

Awards
1991
•Marie Fisher Memorial
Prize for the Advancement
of Young Artists,
Bezalel Academy of Art and
Design, Jerusalem

1992–93
•America-Israel Cultural
Foundation Scholarship,
Tel Aviv

Selected Solo Exhibitions
1992
•*Nature Morte*
Bograshov Gallery, Tel Aviv
1995
•*Virgin of Israel and Her
Daughters*
Artists' House, Jerusalem
1997
•*The Range of Realism*
Tel Aviv Museum of Art

Selected Group Exhibitions
1992
•*Who Is Signed on the Duck?*
Bograshov Gallery, Tel Aviv
1993
•*Third Person*
Bograshov Gallery, Tel Aviv
•*The Range of Realism*
Tel Aviv Museum of Art
1994
•*The Suitcase*
Bograshov Gallery, Tel Aviv
•*From the Collection*
The Israel Museum,
Jerusalem
•*Meta-Sex '94: Identity, Body
and Sexuality*
Mishkan Le'Omanut,
Museum of Art, Ein Harod,
Israel; traveled to the
Museum of Art, Bat Yam,
Israel
•*90>70>90*
Helena Rubinstein Pavilion
for Contemporary Art,
Tel Aviv Museum of Art
•*Tel Hai '94*
Contemporary Art Meeting,
Tel Hai, Upper Galilee,
Israel

•*Bograshov the Street—
Export Surplus*
Bograshov Gallery, Tel Aviv
1995
•*Sculpture, Installation '95*
Israel Festival, Jerusalem
•*New Works*
Noga Gallery of
Contemporary Art, Tel Aviv
1996
•*Marks: Artists Work
Throughout Jerusalem*
The Israel Museum,
Jerusalem
•*Long Memory/ Short
Memory*
City Gallery of
Contemporary Art,
Raleigh, North Carolina
•*Desert Cliché: Israel Now—
Local Images*
Arad Museum, Arad, Israel;
traveled to Mishkan
Le'Omanut, Museum of
Art, Ein Harod, Israel;
Herzliya Museum of Art,
Herzliya, Israel; Bass
Museum of Art, Miami
Beach, Florida; Grey Art
Gallery and Study Center
of New York University,
New York
•*Woman Time*
Artists' House, Haifa
•*Station Transformation,
Project no. 3*
The New Central Bus
Station, Tel Aviv
1997
•*Out of Senses*
MUHKA, Museum of
Modern Art,
Antwerp, Belgium
•*Home*
Gallery Anadiel, The Old
City, Jerusalem

• *O Mama—*
The Representation of
Motherhood in Israeli
Contemporary Art
The Museum of Israeli Art,
Ramat Gan, Israel
1998
• *To the East: Orientalism in*
the Arts in Israel
The Israel Museum,
Jerusalem
• *Between Beauty and*
Destiny: Three Generations
of Israeli Art
Cleveland Center for
Contemporary Art, Ohio
• *Young Israeli Art*
Ministry of Economic
Affairs of North Rhine-
Westphalia,
Düsseldorf, Germany
• *Point of View*
Tel Aviv Museum of Art

Hilla Lulu Lin

HILLA LULU LIN

• Born in 1964, Afula, Israel
• Lives in Kfar Bilu

Education
1986–89
• B.F.A., Bezalel Academy of
Art and Design, Jerusalem

Awards
1988
• Blumenthal Award for
Achievement
• Award for the Design
of a Commercial Object,
The Israel Museum,
Jerusalem
1989
• Blumenthal Award for
Achievement
1992
• Young Artist Prize,
Israel Ministry of Education
and Culture Prize for the
Visual Arts
1988–94
• America-Israel Cultural
Foundation Art Award
1995
• Menashe Kadishman
Award,
America-Israel Cultural
Foundation, Tel Aviv

Selected Solo Exhibitions
1992
• *The Voice of Days*
Bograshov Gallery, Tel Aviv
• *Never Dirty*
The Art Workshop Gallery,
Yavne, Israel
1993
• *Still Lifeless with Cub*
Artifact Gallery, Tel Aviv
1995
• *The Air Has a Sweet Taste*
Nicole Klagsbrun Gallery,
New York
• *A Cow, a Turtle, and a*
Goldfish
Ambrosino Gallery,
Coral Gables, Florida
• *Everything Is 6 Times*
Lighter on the Moon
Artifact Gallery, Tel Aviv
1997
• *Pure and Wild*
Ambrosino Gallery,
Coral Gables, Florida
1998
• *Miles I Would Go*
Haifa Museum of Modern
Art
• *I Am the Queen in the*
Slave's Palace
Artists' Studio, Tel Aviv

Selected Group Exhibitions
1992
• *Who Ate My Porridge?*
The Museum of Israeli Art,
Ramat Gan, Israel
1993
• *Antipathos: Black Humor,*
Irony, and Cynicism in
Contemporary Israeli Art
The Israel Museum,
Jerusalem
• *Eight Artists Recommended*
to the Aperto, Venice '93,
Artifact Gallery, Tel Aviv

1994
• *Gallery Artists*
Artifact Gallery, Tel Aviv
• *The Body Human*
Nora Haime Gallery,
New York
• *Nancy Davenport, Hilla*
Lulu Lin, Melissa Gwyn
Miller
Nicole Klagsbrun Gallery,
New York
• *Pro-Nature, Anti-Nature*
The Third Sculpture
Biennial, Ein Hod, Israel
• *Meta Sex '94: Identity, Body,*
and Sexuality
Mishkan Le'Omanut,
Museum of Art, Ein Harod,
Israel; traveled to the
Museum of Art, Bat Yam,
Israel
• *The Suitcase*
Bograshov Gallery, Tel Aviv
1995
• *Selections 1989–95*
Nicole Klagsbrun Gallery,
New York
• *L'Art d'Amour*
Espace Paul Boyer,
Sète, France
• *The America-Israel Cultural*
Foundation Art Award
Exhibition
The Israel Museum
• *Art Miami*
Miami Beach Convention
Center, Florida
1996
• *Desert Cliché: Israel Now—*
Local Images
Arad Museum, Arad, Israel;
traveled to Mishkan
Le'Omanut, Museum of
Art, Ein Harod, Israel;
Herzliya Museum of Art,
Herzliya, Israel; Bass
Museum of Art, Miami

Beach, Florida; Grey Art
Gallery and Study Center of
New York University
•*Back to You*
Haifa Museum of Modern
Art
•*Delicious Art Exhibition*
Tempozan Contemporary
Art Museum, Osaka, Japan
•*Woman Time*
Artists' House, Haifa
•*Eye Level*
Artists' House, Jerusalem
•*Body of Work*
Ambrosino Gallery,
Coral Gables, Florida
•*Po-Mo Funk:*
Urban Expressions Beyond
Postmodern Theory
Florida Arts Center,
Miami Beach
•*Billboard Project*
Museum Forum,
Herzliya, Israel
•*Art 1996 Chicago*
Navy Pier, Chicago
1997
•*The Tip of the Iceberg*
9th Triennial India,
Lalit Kala Kademi
(National Academy of Art),
New Delhi
•*Blurrr* (performance)
Tel Aviv Performing Arts
Center
•*The Ingenious Machine*
of Nature
The Israel Museum
•*Drawing the Line*
Ambrosino Gallery,
Coral Gables, Florida
1998
•*To the East: Orientalism*
in the Arts in Israel
The Israel Museum,
Jerusalem

Tal Matzliah

TAL MATZLIAH

•Born in 1961, Kibbutz Kfar
Aza, Israel
•Lives in Tel Aviv

Education
1984–88
•The Kalisher School of Art,
Tel Aviv

Awards
1995
•Young Artist Prize,
Israel Ministry of Arts and
Science
1996
•Haddassa and Raphael
Klachkin Award for
Excellence in the Plastic
Arts,
America-Israel Cultural
Foundation, Tel Aviv

Solo Exhibitions
1992
•*English Breakfast*
Mary Fauzi Gallery, Jaffa,
Israel
1995
•*New Works*
Noga Gallery of
Contemporary Art, Tel Aviv

1996
•*Now You Can Throw Me*
to the Dogs
Beit Haham Gallery,
Tel Aviv
1998
•*Ornaments to-*
Noga Gallery of
Contemporary Art, Tel Aviv

Group Exhibitions
1992
•*The Youth*
Mary Fauzi Gallery,
Jaffa, Israel
•*Quiet Oppositions*
Sara Levy Gallery, Tel Aviv
1993
•*Conflict Returns to Drawing*
Sara Konforti Gallery,
Jaffa, Israel
1994
•*Subtropical: Between*
Figuration and Abstraction
Tel Aviv Museum of Art
•*Local Time 1*
Noga Gallery of
Contemporary Art, Tel Aviv
•*Anxiety,* Art Focus
The Museum of Israeli Art,
Ramat Gan, Israel
•*Home-Works*
Herzliya Museum of Art,
Herzliya, Israel; Art Gallery,
Haifa University
•Art Focus
Noga Gallery of
Contemporary Art, Tel Aviv
1995
•*Summer Exhibition*
Noga Gallery of
Contemporary Art, Tel Aviv
•*Autumn Salon*
The Museum of Israeli Art,
Ramat Gan, Israel

•*Young Artist Prize Exhibition*
Artists' House, Tel Aviv
1996
•*Obsession*
Art Gallery, Haifa
University
•*Drawing Exhibition*
Nachson Gallery, Kibbutz
Nachson, Israel
1997
•*A Happy New Year*
Nechama Gallery,
Jaffa, Israel
1998
•*Retail Price*
Pyramid Center of
Contemporary Art, Haifa

Adi Nes

ADI NES

- Born in 1966, Kiryat Gat, Israel
- Lives in Tel Aviv

Education
1989–92
- Bezalel Academy of Art and Design, Jerusalem
1996–97
- Multimedia and Programming Department at Sivian Computer School, Tel Aviv

Selected Solo Exhibitions
1996
- *First Act*
 Photography Department, Bezalel Academy of Art and Design, Jerusalem

Selected Group Exhibitions
1993
- *Jewish Gay Life*
 (Winners of the Anglo-Israeli Photographic Awards), Akehurst Gallery, London
- Artists' House, Jerusalem
- *Adi Nes and Naomi Talisman*
 Photography Gallery, Camera Obscura School of Art, Tel Aviv

1994
- *90>70>90*
 Helena Rubinstein Pavilion for Contemporary Art, Tel Aviv Museum of Art
- *You Are*
 Helena Rubinstein Pavilion for Contemporary Art, Tel Aviv Museum of Art
- *Export Surplus*
 Bograshov Gallery, Tel Aviv
- *No Photography!*
 Bograshov Gallery, Tel Aviv

1996
- *Israeli Diary*
 Tel Aviv Cinematique, Tel Aviv

1997
- *The Israelis*
 School of Visual Art, Beersheva, Israel
- *To Be Taken Captive*
 Photography Museum, Tel Hai, Israel
- *Images of Masculinity*
 Limbus Gallery, Mishkan Le'Omanut, Ramat Hasharon, Israel
- *Who Made Me as He Wishes*
 Camera Obscura School of Art, Tel Aviv

1998
- *Bamot*—the building, destruction, and restoration of High Places (Israel 1948–1998)*
 Vienna Jewish Museum, Austria
- *Capturing Reality: 19 Israeli and Palestinian Photographers*
 Tennessee State Museum, Nashville, Tennessee

Lea Nikel

LEA NIKEL

- Born in 1918, Zhitomir, Ukraine
- Immigrated to Palestine in 1920
- Lives in Moshav Kidron, Israel

Education
1935
- Studied with Chaim Gliksberg
1946–47
- Studied at the Stematsky-Streichman Studio, Tel Aviv

Awards
1968
- Israel Ministry of Education and Culture Prize for the Visual Arts, Jerusalem Exhibition
1972
- Sandberg Prize, The Israel Museum, Jerusalem
1982
- Dizengoff Prize of the Tel Aviv Municipality
1987
- Gamzu Prize, Tel Aviv Museum of Art

Selected Solo Exhibitions
1985
- The Israel Museum, Jerusalem
1987
- *Lea Nikel: Works on Paper*
 The Museum of Israeli Art, Ramat Gan, Israel
1990
- *Lea Nikel*
 Culture Center, Arad, Israel
- *Nikel*
 Givon Art Gallery, Tel Aviv
1992
- *Lea Nikel: Book*
 Helena Rubinstein Pavilion for Contemporary Art, Tel Aviv Museum of Art
- *Nikel—Monoprints*
 The Israel Museum, Jerusalem
- *Lea Nikel—Poems*
 Tel Aviv Museum of Art
1995
- *Lea Nikel—A Retrospective*
 Tel Aviv Museum of Art

Selected Group Exhibitions
1990
- *Frivolous Works by Serious Artists*
 Painters and Sculptors Association, Tel Aviv
- *Drawings and Beyond*
 Givon Art Gallery, Tel Aviv
- *Dialogue with Stematsky*
 Artists' Studio, Tel Aviv
1991–93
- *The Secret of Color Reduction*
 The M. Smilanski Center, Rehovot, Israel; traveled to Yad Lebanim House, Petah Tikva, and other sites in Israel. Organized by the Ministry of Education and Culture, the America-Israel

Cultural Foundation,
and Omanut L'am
1992
•*Positionen Israel*
Künstlerhaus Bethanien,
Berlin
•*Contemporary Israeli
Landscapes*
Expo '92, Arts Pavilion,
Seville, Spain
•*The Art Print*
Sara Levy Gallery, Tel Aviv
•*A Tribute to Ayala—
Israeli Art from the Ayala
Zacks-Abramov Collection*
The Israel Museum,
Jerusalem
•*New Visions*
Barbara Scott Gallery,
Miami, Florida
1993
•*Mutual Feedback*
Florence Miller Art Center,
Jerusalem Print Workshop,
Jerusalem
1994
•*Object Lu*
Janco-Dada Museum,
Ein Hod, Israel
•*The Printer's Imprint—
Twenty Years of the
Jerusalem Print Workshop*
The Israel Museum,
Jerusalem
•Art Miami '93
Barbara Scott Gallery,
Miami, Florida
1994–95
•*The Johannesburg
Biennial—Africus '95*
The 1st Biennial of South
Africa, Johannesburg
1996
•*The Unseen Borders:
Israeli Contemporary Art*
Taipei Fine Arts Museum,
Taipei, Taiwan

MOSHE NINIO

•Born in 1953, Tel Aviv
•Lives in Tel Aviv

**Teaching Positions/
Professional Activities**
1987–
•Video and Moving Image
Program, The Herzliya
Museum of Art, Israel
1988–
•The Kalisher School of Art,
Tel Aviv
•Camera Obscura School
of Art, Tel Aviv
1992
•*Those at Home,
Those in the Yard* (Curator)
The Israel Museum,
Jerusalem
1997
•*Never Did Anything Hard*
(Curator)
The Tel Aviv Museum of
Art

Awards
1987
•George and Janet Jaffin
Award for Excellence in the
Plastic Arts,
America-Israel Cultural
Foundation, Tel Aviv
1989
•Short-Term Study Grant,
America-Israel Cultural
Foundation
1996
•The IsraCard Prize,
Tel Aviv Museum of Art
1997–98
•Ministry of Education and
Culture Prize for Artists
in the Fields of Plastic Art

Solo Exhibitions
1987
•Camera Obscura Gallery,
Tel Aviv
1990
•*Cycle of Days*
The Israel Museum,
Jerusalem
1993
•Marge Goldwater Gallery,
New York
1996
•Frac Languedoc-Roussillon,
Montpellier, France
•Mary Fauzi Gallery, Jaffa,
Israel

Selected Group Exhibitions
1990
•*Space/Presentation/Power*
Bograshov Gallery, Tel Aviv
•*Toward the '90s*
Mishkan Le'Omanut,
Museum of Art, Ein Harod,
Israel
•Photography Department
Gallery, Bezalel Academy of
Art and Design, Jerusalem
•*Life Size: A Sense of the
Real in Recent Art*
The Israel Museum,
Jerusalem
1991
•*Lignes de mire/2*
Cartier Foundation, Paris
•*Persistence of Memory*
The Third Israeli Biennale
of Photography, Mishkan
Le'Omanut, Museum of
Art, Ein Harod, Israel
•*Place & Mainstream:
Contemporary Sculpture
from Israel*
Hara Museum,
Gunma Prefecture, Japan;
traveled to The Museum of

Contemporary Art,
Seoul, Korea
•*Routes of Wandering:
Nomadism, Voyages, and
Transitions in Contemporary
Israeli Art*
The Israel Museum,
Jerusalem
1992
•Documenta IX
Kassel, Germany
•*The Israeli Artists of
Documenta IX*
Haifa University Art
Gallery
1993
•*Ultima*
Yad Lebanim Museum,
Petah Tikva, Israel
•*There*
The Israel Museum,
Jerusalem
•*A Special Selection from the
Collection*
The Israel Museum,
Jerusalem
•*Makom: Contemporary Art
from Israel*
Museum of Twentieth-
Century Art, Vienna
•*Off the Wall*
Jane Baum Gallery,
New York
•*Up Up (and away)*
Here Art Gallery, New York
1994
•*I See This*
Camera Obscura Gallery,
Tel Aviv
•*Confrontations*
Museum of Twentieth-
Century Art, Vienna
•*Strong Emphasis*
The Israel Museum,
Jerusalem
•*Anxiety,* Art Focus
The Museum of Israeli Art,
Ramat Gan, Israel

1994–95
· *Burnt/Whole*
W. P. A., Washington D.C.;
traveled to Institute of
Contemporary Art, Boston
1995
· *Windows*
The Israel Museum,
Jerusalem
1996
· *The Blind Spot Test (II)*
Photography Gallery,
Bezalel Academy of Art and
Design, Jerusalem
· *Dites-le avec des fleurs*
Galerie Chantal Crousel,
Paris
· *Lost and Found*
Mary Fauzi Gallery,
Jaffa, Israel
· *Reopening Show*
Haifa Museum of Modern
Art
· *New Video*
Video Hallan,
Basel, Switzerland
· *Moving*
Project Raum,
Zurich, Switzerland
· *Hide and Seek*
The Teddy Kollek Stadium;
Art Focus Project, Jerusalem
1998
· *Pre-view*
The Israel Museum,
Jerusalem
· *Perspectives on Israeli Art
of the Seventies: Visual Art
in a Country Without
Boundaries*
Tel Aviv Museum of Art
· *The Lesser Light: Images
of Illumination in
Contemporary Israeli Art*
The Israel Museum
· *To the East: Orientalism in
the Arts in Israel*
The Israel Museum

Ibrahim Nubani

IBRAHIM NUBANI

· Born in 1961, Makan
Village, Israel
· Lives in Makan Village,
Israel

Education
1980–84
· Bezalel Academy of Art
and Design, Jerusalem

Solo Exhibitions
1991
· Chelouche Gallery, Tel Aviv
1993
· Chelouche Gallery, Tel Aviv
1995
· Chelouche Gallery, Tel Aviv

Group Exhibitions
1991
· *Israeli Art Now*
Tel Aviv Museum of Art
· Chelouche Gallery, Tel Aviv
1992
· *Israeli Artists*
Opera House,
Leipzig, Germany
1994
· *Local Texture*
Museum Ashdot Yaacov
Meuchad, Jordan Valley,
Israel
1996
· Um al Fachem Art Gallery,
Wadi Aara, Israel

Gilad Ophir

GILAD OPHIR

· Born in 1957, Tel Aviv
· Lives in Tel Aviv

Education
1979–80
· Tel Aviv University, Tel Aviv
1980–81
· Bezalel Academy of Art
and Design, Jerusalem
1981–84
· B.F.A., School of Visual
Arts, New York
1984–86
· M.F.A., Hunter College,
New York

Awards
1986
· The William Graf
Scholarship,
Hunter College, New York
1991–92
· America-Israel Cultural
Foundation Scholarship,
Tel Aviv
1992
· The Gérard Levy Prize,
The Israel Museum,
Jerusalem
1995
· The prize for the
completion of a work,
Department of Visual Art,
Public Council of Culture
and Art

Selected Solo Exhibitions
1988
- *Photographs*
Bertha Urdang Gallery,
New York

1991
- *The Monads Are Windowless*
Bezalel Academy of Art
and Design, Jerusalem

1992
- Camera Obscura Gallery,
Tel Aviv

1993
- *Brutus Twice*
Machanaim Gallery,
Kibbutz Machanaim, Israel

1995
- *Cylopean Walls*
Tel Aviv Museum of Art

Selected Group Exhibitions
1990
- *Photographs 1988–1990*
Artists' Studio, Tel Aviv

1991
- *New York in the
Photography Collection*
Tel Aviv Museum of Art
- *Persistence of Memory*
The Third Israeli Biennale
of Photography, Mishkan
Le'Omanut, Museum
of Art, Ein Harod, Israel

1992
- *Stations on the way to the
completed work and from it*
Tel Aviv Museum of Art
- *Winners of the America-
Israel Cultural Foundation
Sharett Scholarship
Exhibition*
The Museum of Israeli Art,
Ramat Gan, Israel

1993
- *Range of Realism:
Contemporary Israeli
Photography*
Tel Aviv Museum of Art
- *Locus: Contemporary Art
from Israel*
Fisher Gallery, University
of Southern California,
Los Angeles

1994
- *90>70>90*
Helena Rubinstein Pavilion
for Contemporary Art,
Tel Aviv Museum of Art
- *Anthropologists*
The New Art Workshop,
Ramat Eliyahu,
Rishon Le Zion, Israel
- *Joker,* Art Focus,
installation/performance
within *Photography:
8 artists, 8 spaces,
8 installations*
The Israel Museum,
Jerusalem

1995
- *Bertha Urdang Collector's
Choice: From the '70s
Till Today*
Daphna Naor
Contemporary Art,
Jerusalem
- *Neither Here Nor There*
Gordon Gallery, Tel Aviv
- *Contact Point
Photography—Poetry*
Bezalel Academy of Art
and Design, Jerusalem
- *New Acquisitions in
Photography*
The Israel Museum,
Jerusalem
- *A Station in Motion*
Central Bus Station,
Tel Aviv

1996
- *Contemporary Israeli
Photography*
Hildesheim Museum,
Germany
- *Eight Contemporary Israeli
Photographers*
Städtische Galerie,
Delmenhorst, Germany
- *A Delicate Balance:
Six Israeli Photographers*
The Light Factory,
Charlotte, North Carolina
- Borochov Gallery, Tel Aviv
(project with Roi Kuper)
- The Israel Museum,
Jerusalem (project with
Roi Kuper)

1997
- *Photographes d'Israel*
Passage de Retz, Paris
- *The Institute for
Contemporary Photography*
Photograph Biennial,
Tokyo
- *Desert Cliché: Israel Now—
Local Images*
Arad Museum, Arad, Israel;
traveled to Mishkan
Le'Omanut, Museum of
Art, Ein Harod, Israel;
Herzliya Museum of Art,
Herzliya, Israel; Bass
Museum of Art, Miami
Beach, Florida; Grey Art
Gallery and Study Center
of New York University,
New York
- *Landscape*
The Ramat Gan Museum
for Israeli Art, Ramat Gan,
Israel

1998
- *Condition Report*
The Israel Museum,
Jerusalem

- *Bamot*—the building,
destruction, and restoration
of High Places (Israel
1948–1998)*
Vienna Jewish Museum,
Austria
- Noga Gallery of
Contemporary Art, Tel Aviv
(project with Roi Kuper)

David Reeb

DAVID REEB

- Born in 1952, Rehovot, Israel
- Lives in Tel Aviv

Education
1975–78
- Bezalel Academy of Art and Design, Jerusalem

Teaching Positions
1983–86
- Yavne Arts Workshop, Yavne, Israel
1990
- University of Haifa
1986–
- The Kalisher School of Art, Tel Aviv
- The Camera Obscura School of Art, Tel Aviv

Awards
1983
- The Jacques and Eugenie Ohanna Prize for a Young Israeli Artist, Tel Aviv Museum of Art
1990
- Israel Ministry of Education and Culture Prize for the Visual Arts

1991
- George and Janet Jaffin Award for Excellence in the Plastic Arts, America-Israel Cultural Foundation, Tel Aviv
1995
- The Sandberg Prize, The Israel Museum, Jerusalem
1996
- Eugene Kolb Award, Tel Aviv Museum of Art

Selected Solo Exhibitions
1989
- Artifact Gallery, Tel Aviv
1990
- Artifact Gallery, Tel Aviv
- Artists' Studio, Tel Aviv
- Gimel Gallery, Jerusalem
1991
- Gimel Gallery, Jerusalem
1992
- Artists' Studio, Tel Aviv
1993
- Bograshov Gallery, Tel Aviv
- Städtische Kunsthalle, Düsseldorf, Germany
1994
- Tel Aviv Museum of Art
1995
- Dvir Gallery, Tel Aviv
1996
- Mary Fauzi Gallery, Jaffa Israel
1996–97
- *Left and Right* Har-El Print Workshop, Tel Aviv
1997
- Rachel and Israel Pollak Gallery, Tel Aviv

Selected Group Exhibitions
1988–93
- *It's Possible: Israeli and Palestinian Artists Call for a Two-State Solution* Traveling exhibition in the United States, Japan, and Germany
1990
- Asian-European Art Biennale, Ankara, Turkey
1991
- *Israeli Art Around 1990* Städtische Kunsthalle, Düsseldorf, Germany; traveled to Artists' House, Moscow; The Israel Museum, Jerusalem
1992
- *Postscripts: "End" Representations in Contemporary Israeli Art* The Genia Schreiber University Art Gallery, Tel Aviv University
- *Olive Green* Bograshov Gallery, Tel Aviv
- Mary Fauzi Gallery, Jaffa Israel
1993
- *Subtropical: Between Figuration and Abstraction* Tel Aviv Museum of Art
1994
- *12 Israeli and Palestinian Artists* Strasbourg, France
1995
- *Building Bridges* Meridian House, Washington D.C., and other venues in the United States
- *States of Being* Institute of Contemporary Art, Boston

1996
- Mary Fauzi Gallery, Jaffa Israel
- *Windows* The Israel Museum, Jerusalem
- *Flesh and Word* University of North Carolina, Chapel Hill
1996–97
- *Desert Cliché: Israel Now— Local Images* Arad Museum, Arad, Israel; traveled to Mishkan Le'Omanut, Museum of Art, Ein Harod, Israel; Herzliya Museum of Art, Herzliya, Israel; Bass Museum of Art, Miami Beach, Florida; Grey Art Gallery and Study Center of New York University, New York
1997
- Givon Art Gallery, Tel Aviv
1998
- Dvir Gallery, Tel Aviv
- *To the East: Orientalism in the Arts in Israel* The Israel Museum, Jerusalem
- *The Lesser Light: Images of Illumination in Contemporary Israeli Art* The Israel Museum, Jerusalem

Simcha Shirman

SIMCHA SHIRMAN

- Born in 1947,
 St. Ottilien, Germany
- Immigrated to Israel
 in 1948
- Lives in Tel Aviv

Education
1972–76
- B.F.A., School of Visual
 Arts, New York
1976–78
- M.F.A., Pratt Institute,
 Brooklyn, New York

Teaching Positions
1980–
- Bezalel Academy of Art
 and Design, Jerusalem
1979–
- Beit Berl College for Art
 Teachers, Ramat Hasharon,
 Israel

Awards
1984
- Artist-in-Residence,
 Pratt Institute,
 Brooklyn, New York
1986
- Enrique Kabline
 Photography Grant,
 The Israel Museum,
 Jerusalem

1992
- George and Janet Jaffin
 Award for Excellence in
 the Plastic Arts,
 America-Israel Cultural
 Foundation, Tel Aviv
1995
- The Freedom for Israel
 Prize,
 The Anni and Heinrich
 Sussmann Foundation,
 Vienna

Selected Solo Exhibitions
1994
- *From the Wanderings
 of the One-Armed Rider,
 S.S. 470430–920430*
 The Museum of Israeli Art,
 Ramat Gan, Israel; traveled
 to San Francisco
 Camerawork, San Francisco
- *Art and Reality*
 International Photography
 Center, Plovdiv, Bulgaria
1997
- *I Am a Japanese*
 Sotheby's Fine Arts, Tel Aviv
- *Exploring the Diversity*
 The 2nd Tokyo
 International Photo-
 Biennial, Japan
- *13*
 The Museum of Israeli Art,
 Ramat Gan, Israel

Selected Group Exhibitions
1991
- *Israeli Artists at the Tel Aviv
 Museum of Art*
 Tel Aviv Museum of Art
- *The Presence of the Absent:
 The Empty Chair in Israeli
 Art*
 The Genia Schreiber
 University Art Gallery,
 Tel Aviv University

1992
- *Postscripts: "End"
 Representations in
 Contemporary Israeli Art*
 The Genia Schreiber
 University Art Gallery,
 Tel Aviv University
- *Patterns of Jewish Life:
 Jewish Thought and Beliefs,
 Life and Work within the
 Cultures of the World*
 Martin Gropius-Bau, Berlin
1994
- *Icarus Myth*
 Camera Obscura Gallery,
 Tel Aviv
- *Exclamation Mark* (books),
 Janco-Dada Museum,
 Ein Hod, Israel
- *Photographic
 Contemporaire: La Matière,
 L'Ombre, La Fiction*
 Bibliothèque Nationale de
 France, Paris
- *Anxiety,* Art Focus
 The Museum of Israeli Art,
 Ramat Gan, Israel
1995
- *The Unseen Borders:
 Israeli Contemporary Art*
 Taipei Fine Arts Museum,
 Taiwan; Waikato Museum
 of Art and History,
 Hamilton, New Zealand
1996
- *A Delicate Balance:
 Six Israeli Photographers*
 The Light Factory,
 Charlotte, North Carolina
1997
- *Landmark*
 The Museum of Israeli Art,
 Ramat Gan, Israel

1998
- *Condition Report:
 Photography in Israel
 Today*
 The Israel Museum,
 Jerusalem
- *Capturing Reality:
 19 Israeli and Palestinian
 Photographers*
 The Tennessee State
 Museum, Nashville,
 Tennessee
- *To the East: Orientalism in
 the Arts in Israel*
 The Israel Museum,
 Jerusalem

Doron Solomons

DORON SOLOMONS

- Born in 1969, London
- Immigrated to Israel in 1974
- Lives in Ramat Gan, Israel

Education
1991–94
- Beit Berl College for Art Teachers, Ramat Hasharon, Israel

Selected Group Exhibitions
1994
- *Painting Above and Beyond* The Museum of Israeli Art, Ramat Gan, Israel
- *Nine Young Artists* Nofar Gallery, Tel Aviv

1997
- *135 silences and 3 sentences* Herzliya Art Museum, Herzliya, Israel
- Museum Ashdot Yaacov Meuchad, Jordan Valley, Israel
- Camera Obscura Gallery, Tel Aviv

1998
- *Five* Artists Association of Israeli, Tel Aviv

Igael Tumarkin

IGAEL TUMARKIN

- Born in 1933, Dresden, Germany
- Immigrated to Palestine in 1935
- Lives in Jaffa, Israel

Education
1945
- Technical School, Tel Aviv

1954
- Studied sculpture with Rudi Lehmann at Ein Hod

Awards
1963
- First Prize, Hulekat Monument Competition

1964
- The Holocaust Monument, Upper Nazareth

1968
- Sandberg Prize, The Israel Museum, Jerusalem
- First Prize, Seamen Monument Competition, Haifa

1971
- First Prize, Monument of the Holocaust and Revival, Tel Aviv

1972
- For the Fallen, the Jordan Valley

1978
- Rijeka International Drawing Show, Yugoslavia

1984
- Cavaliere Ufficiale nell'Ordine al Merito della Repubblica Italiana, given by the Italian president

1990
- Guest of the Japan Foundation

1992
- The Rodin Grand Prize, The 4th Rodin Grand Prize competition, The Hakone Open-Air Museum, Hakone, Japan

1997
- Das Vedientskreuz des Verdientsordens der Bundesrepublik Deutschland, given by the German president

1998
- The Freedom for Israel Prize, The Anni and Heinrich Sussmann Foundation, Vienna

Solo Exhibitions
1991
- Herzliya Museum, Herzliya, Israel

1992
- *Tumarkin 1957–92* Retrospective, Tel Aviv Museum of Art

1993
- *Prints and Small Sculptures*
 Har-El Publishers and
 Printers, Jaffa, Israel
- *Reliefs, Drawings, Graphics*
 Evangelische Akademie,
 Arnoldshain, Germany

1994
- *Demi-Retrospective*
 The Loft, Hangar no. 1,
 Jaffa port, Israel
- *The Hakone Open-Air
 Museum*, Japan

1995
- *The Holy, the Profane,
 the Art*
 Evangelische Akademie,
 Loccum, Germany
- *The Marcel Gordon
 University Club*, Tel Aviv
 University
- *Sculptures, Drawings,
 and Graphics*
 Nanu Gallery,
 Frankfurt, Germany
- *Drawings for "David" by
 B. Brecht*
 Raab Gallery, Berlin

1996
- *Pillar, Cross, Sign*
 The Museum of Israeli Art,
 Ramat Gan, Israel

1997
- *Mein blaues Klavier—
 Für Else Lasker-Schüler*
 Mabat Gallery, Tel Aviv
- *Five Floor Sculptures and a
 Metamorphose*
 Mary Fauzi Gallery, Jaffa,
 Israel
- *Meningitis Blue*
 L'Institut Français, Tel Aviv

1998
- *Sculptures at Brekhat
 ha'Sultan*
 The International Art and
 Crafts Fair, Jerusalem

Group Exhibitions
1990
- *Nature Has Built Us
 a Museum*
 Ein Hod, Israel

1991
- *Bertolt Brecht*
 Berlin Museum, Berlin
- *Israeli Art Now*
 Tel Aviv Museum of Art

1994
- *He! Bonjour, Monsieur
 La Fontaine*
 Bibliothèque et Musée,
 Brest, France; traveled to
 Nantes, France, and
 Amman, Jordan
- *Le Temps de l'Ailleurs
 (Mlynarcik)*
 Galerie Lara Vincy, Paris

1995
- *From the Rita and Arturo
 Schwarz Collection of
 Israel Art*
 The Israel Museum,
 Jerusalem
- *"Sieh in mein verwandertes
 Gesicht": For Else Lasker-
 Schüler, 50 Years after Her
 Death*
 Wuppertal, Germany, and
 Zurich, Switzerland
- *Power Plant Exhibition*
 Eretz Israel Museum,
 Tel Aviv

1996
- *Windows: Glimpses of Seven
 Themes in Israeli Art*
 The Israel Museum,
 Jerusalem
- *Saint-Exupéry: Le désert
 et le petit prince*
 Nantes, France
- *Map of a Memory*
 Eretz Israel Museum,
 Tel Aviv

1997
- *Amnesty International,
 Israel section, Tel Aviv*
- *Painting on Non-Regular
 Surfaces*
 Givon Art Gallery, Tel Aviv

1998
- *Rund um Brecht*
 Galerie Pels-Leusden, Berlin
- *Perspectives on Israeli Art
 of the Seventies: The
 Boundaries of Language*
 Tel Aviv Museum of Art
- *Bamot*—the building,
 destruction, and restoration
 of High Places (Israel
 1948–1998)*
 Vienna Jewish Museum,
 Austria
- *In the Light of the Menorah*
 The Israel Museum,
 Jerusalem
- *To the East: Orientalism
 in the Arts in Israel*
 The Israel Museum,
 Jerusalem

Uri Tzaig

URI TZAIG

- Born in 1965, Kiryat Gat,
 Israel
- Lives in Tel Aviv

Education
1990
- Graduated from the
 School of Visual Theater,
 Jerusalem

Professional Activities
1992
- Retrospectives on Theatrical
 Objects (Curator), Van Leer
 Institute, Jerusalem

1995–96
- Artist in Residence,
 University Art Museum,
 Berkeley, California

1993–94
- Artist in Residence,
 Künstlerhaus Bethanien,
 Berlin

Awards
1992–93
- America-Israel Cultural
 Foundation Scholarship,
 Tel Aviv

1995–96
- America-Israel Cultural
 Foundation Scholarship,
 Tel Aviv

Selected Solo Exhibitions

1990
- *Monologue*
 Artists' House, Jerusalem

1991
- *Shelters*
 The Judah L. Magnes
 Museum,
 Berkeley, California

1993
- *Tel Aviv, Summer 1992*
 Bograshov Gallery, Tel Aviv

1995
- *The Earrings of Eva Braun*
 Künstlerhaus Bethanien,
 Berlin
- *Migrateurs*
 Musée d'Art Moderne de
 la Ville de Paris

1996
- *Derby—Lod 1996*
 Artist-in-Residence Project,
 Omanut La'am, Lod, Israel
- *Homeless*
 University Art Museum,
 Berkeley, California
- Refusalon Gallery,
 San Francisco

1997
- *Play*
 Museum of Modern Art,
 Ljubljana, Slovenia
- Refusalon Gallery,
 San Francisco
- *Boats & Islands*
 Galerie Erna Hecey,
 Luxembourg
- Galerie Mot & Van den
 Boogaard, Brussels, Belgium

1998
- Unlimited Gallery,
 Athens, Greece
- Video Projection at the
 Künstlerwerkstatt
 Lothringerstrasse,
 Munich, Germany

- *Manifesta 2*
 Galerie Erna Hecey,
 Luxembourg
- *Tempo*
 De Vleeshal, Middleburg,
 Netherlands

Selected Group Exhibitions

1992
- *Six Rooms*
 Sara Konforti Gallery,
 Jaffa, Israel
- *Sculptures from the
 Museum's Collection*
 Tel Aviv Museum of Art

1993
- *The Israeli Suggestion to the
 Venice's Aperto*
 Artifact Gallery, Jaffa
- *Touching*
 International Poet's Festival,
 Jerusalem
- *Those at Home,
 Those in the Yard*
 The Israel Museum,
 Jerusalem

1994
- David MacClain Gallery,
 Houston, Texas
- *This Is the Show and the
 Show Is Many Things*
 Museum of Contemporary
 Art, Ghent, Belgium

1995
- *Neither Here Nor There*
 Gordon Gallery, Tel Aviv
- *Accrochage*
 Richard Foncke Gallery,
 Ghent, Belgium
- Israeli Pavilion,
 Venice Biennale

1996
- *EV+A*
 Limerick, Ireland
- *Manifesta 1*
 The European Biennial,
 Rotterdam, Holland

- *Hide and Seek*
 Art Focus, Jerusalem
- *We* (with Fabrice Hybert)
 The Israel Museum,
 Jerusalem

1997
- *Touch for Seeing*
 Thiers, France
- *Out of Senses*
 MUHKA, Museum of
 Modern Art,
 Antwerp, Belgium
- *Connexion Implicités*
 Ecole des Beaux Arts, Paris
- French Pavilion (guest of
 Fabrice Hybert),
 Venice Biennale
- Documenta X
 Kassel, Germany
- *Unmapping the Earth*
 Kwangiu Biennale, South
 Korea

1998
- *Loplop/re/presents:
 the impulse to see*
 Boymans van Beuningen,
 Rotterdam, Netherlands
- *Adopt-A-Highway*
 Dogenhaus Gallery,
 Leipzig, Germany
- *Esperanto '98*
 Jack Tilton Gallery,
 New York
- *Israeli Art from Bay Area
 Collections*
 The Jewish Museum,
 San Francisco
- *Football and Nonfictional
 Film*
 Dokumentarfilminitiative,
 Mülheim/Ruhr, Germany
- *Medialization*
 Group exhibition at Edsvik
 Konst och Kultur,
 Sollentuna, Sweden

- *"Kadima"—The East in
 Israeli Art*
 The Israel Museum,
 Jerusalem
- *The Earth Is Round—
 New Narration*
 Musée d'Art Contemporain,
 Rochechouart, France
- *To the East: Orientalism in
 the Arts in Israel*
 The Israel Museum,
 Jerusalem

Micha Ullman

MICHA
ULLMAN

- Born in 1939, Tel Aviv
- Lives in Ramat Hasharon, Israel

Education
1960–64
- Bezalel Academy of Art and Design, Jerusalem
1965
- Central School for Arts and Crafts, London

Teaching Positions
1970–78
- Bezalel Academy of Art and Design, Jerusalem
1976
- Guest Teacher at the Hochschule für Bildende Künste, Düsseldorf, Germany
1979
- Fine Arts Department, Haifa University
1991
- Akademie der Bildende Künste, Stuttgart, Germany

Awards
1963
- Sonborn Prize of the Bezalel Academy of Art and Design, Jerusalem

1972
- Beatrice S. Kolliner Prize for a Young Israeli Artist, The Israel Museum, Jerusalem
1980
- Sandberg Prize for an Israeli Artist, The Israel Museum, Jerusalem
1985
- Mendel and Eva Pundik Prize for Israeli Art, Tel Aviv Museum of Art, Tel Aviv
1995
- Käthe Kollwitz Prize, Akademie der Künste, Berlin
1996
- The Freedom for Israel Prize, The Anni and Heinrich Sussmann Foundation, Vienna
1998
- George and Janet Jaffin Award for Excellence in the Plastic Arts, America-Israel Cultural Foundation, Tel Aviv

Selected Solo Exhibitions
1993
- *Het Apollonis* Eindhoven, Netherlands
- Givon Art Gallery, Tel Aviv
- Kibbutz Machanaim Gallery, Israel
1994
- *Neumond, Bodenskulptur und Monat Zeichnungen* Akademie Schloss Solitude, Stuttgart, Germany
1995
- *Monat Zeichnungen* Galerie Cora Holzl, Düsseldorf, Germany

- Käthe Kollwitz Prize Exhibition, Akademie der Künste, Berlin
1996
- *Drawings 1994–95* Tel Aviv Museum of Art

Selected Group Exhibitions
1991
- *Israeli Art Around 1990* Städtische Kunsthalle, Düsseldorf, Germany; traveled to Artists' House, Moscow; The Israel Museum, Jerusalem
- *Routes of Wandering: Nomadism, Voyages and Transitions in Contemporary Israeli Art* The Israel Museum, Jerusalem
1992
- *Place and Mainstream: Israel Contemporary Sculpture*
- Fukuoka Art Museum, Japan
- National Museum for Contemporary Art, Korea
- Documenta IX Kassel, Germany
- *Beyond Logos* Museum of Modern Art, Belgrade, Yugoslavia
- *The Israeli Artists of Documenta IX* Gallery of Art, Haifa University
1993
- *Makom: Zeitgenössisches Kunst aus Israel* Museum Moderner Kunst, Palais Lichtenstein, Vienna
- *Collectors Choice 2: Geographic Ambivalence* Shafir-Kalmar Gallery, New York

- *Zeichnungen setzen Zeichen 44 Artists of Documenta IX*, Galerie Raymond Bollag, Zurich
1994
- *Fünfter Mai-Salon, Kunst in Berlin* Im neuen Kunstquartier, Berlin
- *Along New Lines: Israeli Drawings Today* The Israel Museum, Jerusalem
- *Emphasis* The Israel Museum, Jerusalem
- *Pro-nature, Anti-nature* The Third Sculpture Biennial, Ein Hod, Israel
- Basel Art Fair, Switzerland
- Givon Art Gallery, Tel Aviv
- *Israeli Sculpture in Tefen, The Last Decade* Art Focus The Open Museum, Industrial Park, Tefen, Israel
1995
- *Co-Existence: Construction in Process* Mizpe Ramon, Israel
- *Where Is Abel Thy Brother?* National Gallery of Contemporary Art, Warsaw
- *Observation Fredssculptur,* Atlanticwall, Jutland, Denmark
- Köln Art Fair, Galerie Cora Hölzl, Düsseldorf, Germany
- *Orientation* Istanbul Biennial IV, Istanbul
- *Intervention* Museo de las Bellas Artes, Caracas, Venezuela

1996

•*Long Memory/Short
Memory*
City Gallery of
Contemporary Art,
Raleigh, North Carolina

1998

•*To the East: Orientalism in
the Arts in Israel*
The Israel Museum,
Jerusalem

Pavel Wolberg

PAVEL WOLBERG

•Born in 1966, Leningrad,
USSR
•Immigrated to Israel
in 1973
•Lives in Tel Aviv

Education

1990–94

•Camera Obscura School
of Art, Tel Aviv

Awards

1994–96

•America-Israel Cultural
Foundation Art
Scholarship, Tel Aviv

1997

•Gérard Levy Prize,
The Israel Museum,
Jerusalem

Solo Exhibitions

1995

•Herzliya Museum of Art,
Herzliya, Israel

1997

•Dvir Gallery, Tel Aviv

Group Exhibitions

1996

•*Contemporary Photography
in Israel*
Beit Ha'amudim, Tel Aviv;

traveled to Camera
Obscura, Tel Aviv;
Borochov Gallery, Tel Aviv

1997

•Borochov Gallery, Tel Aviv
•Dvir Gallery, Tel Aviv

1998

•*The Lesser Light: Images
of Illumination in
Contemporary Israeli Art*
The Israel Museum,
Jerusalem

Catalogue of the Exhibition

*Height precedes width
precedes depth.*

AYA & GAL
Prince of Persia 1995
Video
10 minutes, 30 seconds
Lent by the artists, Tel Aviv
PLATE 1

IDO BAR-EL
Untitled 1994
Mixed media on aluminum
street sign
31 ½ x 31 ½ in. (80 x 80 cm)
Lent by Givon Art Gallery Ltd.,
Tel Aviv
PLATE 21

IDO BAR-EL
Untitled 1995
Industrial paint on aluminum
street sign
39 ⅜ x 49 ¼ in. (100 x 125 cm)
Lent by Givon Art Gallery Ltd.,
Tel Aviv

IDO BAR-EL
Untitled 1996
Mixed media on aluminum
street sign
45 ¼ x 49 ¼ in. (115 x 125 cm)
Lent by Givon Art Gallery Ltd.,
Tel Aviv

AVNER BEN-GAL
Lines 1996
Mixed media on canvas
19 ⁵⁄₁₆ x 27 ⅜ in. (49 x 69 cm)
Private collection, Tel Aviv
PLATE 14

AVNER BEN-GAL
Ort Against Amal 1996
Oil on canvas
47 ¼ x 39 ⅜ in. (120 x 100 cm)
Private collection, Tel Aviv

PINCHAS COHEN GAN
From Herzl to Rabin to Infinity 1995
Cardboard, acrylic, wood, and Xerox
41 ¾ x 30 x 2 in. (106 x 76 x 5 cm)
Lent by the artist, Tel Aviv
PLATE 9

NURIT DAVID
Buba 1997
Oil on canvas
51 ⅛ x 37 ⅜ in. (130 x 95 cm)
Collection Orly and Avishai Shachar,
New York

NURIT DAVID
Buba and Thistle 1997
Oil on canvas
51 ⅛ x 37 ⅜ in. (130 x 95 cm)
Lent by Givon Art Gallery Ltd.,
Tel Aviv
PLATE 32

NURIT DAVID
Stork 1997
Oil on canvas
51 ⅛ x 37 ⅜ in. (130 x 95 cm)
Lent by Givon Art Gallery Ltd.,
Tel Aviv

BELU-SIMION FAINARU
Traffic Light to Heaven 1997
Traffic light, video, 14-inch television,
and electric timer
59 x 15 ¾ x 15 ¾ in. (150 x 40 x 40 cm)
Lent by the artist, Haifa
PLATE 27

BELU-SIMION FAINARU
If I Forget You Jerusalem 1998
Refrigerator, dress, neon light,
earth, and black oil
47 ¼ x 23 ⅝ x 19 ⅝ in.
(120 x 60 x 50 cm)
Lent by the artist, Haifa

BARRY FRYDLENDER
Birth of a Nation 1997–98
Digital transparency on photographic
paper, mounted on Plexiglas, stainless
steel, and fluorescent light
19 ¹¹⁄₁₆ x 78 ¾ x 6 ¾ in.
(50 x 200 x 17 cm)
Lent by the artist, Tel Aviv
PLATE 2

GIDEON GECHTMAN
Still Life no. 6, The Peacock 1994
Stuffed bird, marble, and artificial
marble
Bird: 27 ½ x 43 ¼ x 15 ¾ in.
(70 x 110 x 40 cm)
Table: 26 x 37 ⅜ x 20 in.
(66 x 95 x 51 cm)
Lent by the artist, Rishon Le Zion
PLATE 26

GIDEON GECHTMAN
Hedva 1996
Bronze and porcelain
Six figures, each 11 ½ x 6 x 4 ½ in.
(29.2 x 15.2 x 11.4 cm)
Private collection, Tel Aviv

MOSHE GERSHUNI
After the Shiva 1995
Mixed media on canvas
39 ⅜ x 39 ⅜ in. (100 x 100 cm)
Collection The Israel Museum,
Jerusalem. Acquisition,
Dov and Rachel Gottesmann Fund
PLATE 10

MOSHE GERSHUNI
Kaddish (by Allen Ginsberg) 1997
Silkscreen with hand-laid gold leaf
Edition of 45
20 ½ x 27 ½ in. (52 x 70 cm)
26 pages, 24 images
Lent by Har-El Printers and
Publishers, Jaffa

PESI GIRSCH
Untitled 1997
Gelatin silver print
11 x 17 in. (27.9 x 43.2 cm)
Lent by the artist, Tel Aviv

PESI GIRSCH
Untitled 1997
Gelatin silver print
11 x 17 in. (27.9 x 43.2 cm)
Lent by the artist, Tel Aviv

PESI GIRSCH
Untitled 1997
Gelatin silver print
11 x 17 in. (27.9 x 43.2 cm)
Lent by the artist, Tel Aviv

PESI GIRSCH
Untitled 1997
Gelatin silver print
11 x 17 in. (27.9 x 43.2 cm)
Lent by the artist, Tel Aviv
PLATE 24

PESI GIRSCH
Untitled 1997
Gelatin silver print
11 x 17 in. (27.9 x 43.2 cm)
Lent by the artist, Tel Aviv

ISRAEL HERSHBERG
Stern 1995
Oil on canvas, mounted on wood
25 ⅜ x 19 in. (64 .4 x 48.3 cm)
Private collection, New York
PLATE 33

ISRAEL HERSHBERG
Duet 1996
Oil on canvas, mounted on wood
18 ½ x 13 ⅝ in. (47 x 34.6 cm)
Collection Arnie and Nechami
Druk, New York

NIR HOD
Do You Think I Am a Narcissist? 1997
Oil on canvas
82 x 63 in. (208.3 x 160 cm)
Lent by the artist, courtesy of
LiebmanMagnan, New York

NIR HOD
I Swear 1997
Retouched color photograph
43 ⁵⁄₁₆ x 63 in. (110 x 160 cm)
Private collection, Tel Aviv

NIR HOD, with RON KEDMI
Israeli Soldier 1998
Black-and-white photograph
on silver paper
63 x 47 ¼ in. (160 x 120 cm)
Lent by the artist, Tel Aviv
PLATE 3

JOEL KANTOR
Waiting for the Messiah, Jerusalem 1995
Gelatin silver print
19 ¹¹⁄₁₆ x 23 ⁵⁄₈ in. (50 x 60 cm)
Lent by the artist, Tel Aviv

JOEL KANTOR
Hannover 1996
Gelatin silver print
19 ¹¹⁄₁₆ x 23 ⁵⁄₈ in. (50 x 60 cm)
Lent by the artist, Tel Aviv
PLATE 28

JOEL KANTOR
Tel Aviv 1997
Gelatin silver print
19 ¹¹⁄₁₆ x 23 ⁵⁄₈ in. (50 x 60 cm)
Lent by the artist, Tel Aviv

JOEL KANTOR
Untitled 1997
Gelatin silver print
19 ¹¹⁄₁₆ x 23 ⁵⁄₈ in. (50 x 60 cm)
Lent by the artist, Tel Aviv

ZVIKA KANTOR
Tiger at Midnight 1994
Wood, light bulb, glass, iron, and plastic
43 ¼ x 22 ½ x 11 ¾ in.
(110 x 57 x 30 cm)
Lent by the artist, courtesy Noga
Gallery of Contemporary Art,
Tel Aviv

ZVIKA KANTOR
Big Fishes Eat Small Fishes 1998
Wood, tubing, and bucket
6 x 61 x 8 ¼ in. (15 x 155 x 21 cm)
Lent by the artist, courtesy Noga
Gallery of Contemporary Art,
Tel Aviv
PLATE 20

URI KATZENSTEIN
Love Dub 1994–95
Oil on bronze
25 ⁵⁄₈ in. high (65 cm)
Lent by Givon Art Gallery Ltd.,
Tel Aviv
PLATE 29

URI KATZENSTEIN
Love Dub 1994–95
Oil on bronze
25 ⁵⁄₈ in. high (65 cm)
Lent by Givon Art Gallery Ltd.,
Tel Aviv

URI KATZENSTEIN
Love Dub 1994–95
Oil on bronze
25 ⅝ in. high (65 cm)
Lent by Givon Art Gallery Ltd.,
Tel Aviv

ROI KUPER
Abandoned Army Camp
(from the **Necropolis** series) 1997
Gelatin silver print
49 ¼ x 49 ¼ in. (125 x 125 cm)
Lent by the artist, courtesy Noga
Gallery of Contemporary Art,
Tel Aviv

ROI KUPER
Abandoned Army Camp
(from the **Necropolis** series) 1997
Gelatin silver print
49 ¼ x 49 ¼ in. (125 x 125 cm)
Lent by the artist, courtesy Noga
Gallery of Contemporary Art,
Tel Aviv
PLATE 16

MOSHE KUPFERMAN
Mourning for Rabin 1996
Oil on canvas
51 ⅛ x 76 ¾ in. (130 x 195 cm)
Lent by the artist,
Kibbutz Lochamei Hagetaot
PLATE 11

RAFFI LAVIE
Untitled 1996
Acrylic on plywood
49 ¼ x 48 in. (125 x 122 cm)
Collection Rabin Memorial Peace
Center, donated by the Givon
Family, Tel Aviv
PLATE 12

MERILU LEVIN
Untitled 1994
Oil on board
19 ¹¹⁄₁₆ x 23 ⅝ in. (50 x 60 cm)
Collection Roni and Yael Braun,
Givataim
PLATE 31

MERILU LEVIN
No. 1 from **Uga-Uga-Uga** Series 1997
Oil on metal baking pan
7 ⅞ in. diameter (20 cm)
Lent by the artist, courtesy Noga
Gallery of Contemporary Art,
Tel Aviv

MERILU LEVIN
Untitled 1997
Oil on ceramic
6 x 4 ¾ x 6 in. (15 x 12 x 15 cm)
Lent by the artist, courtesy Noga
Gallery of Contemporary Art,
Tel Aviv

MERILU LEVIN
Untitled 1997
Oil on household iron
9 ½ x 5 in. (24.1 x 12.7 cm)
Lent by the artist, courtesy Noga
Gallery of Contemporary Art,
Tel Aviv

LIMBUS GROUP
Embroideries of Generals 1997
Digital print on canvas
Fifteen works, each 11 x 17 in.
(27.9 x 43.2 cm)
Lent by the artists, Tel Aviv
PLATE 4

ARIANE
LITTMAN-COHEN
Holy Land for Sale, Holy Air and
Holy Water from **Pro visions** 1998
Soil, air, water, soil, paper, linen string,
tin, wax, and plastic
Holy Land for Sale, 1996
each 5 ½ x 7 ½ in. (14 x 19 cm)
Holy Air, 1996
Each 4 ½ x 3 ⅜ in. diameter
(11.5 x 8.5 cm)
Holy Water, 1998
Each 8 ⅝ x 2 ⅜ in. diameter
(22 x 6 cm)
Lent by the artist, Jerusalem
PLATE 19

HILLA LULU LIN
No More Tears 1994
Video
5 minutes, 30 seconds
Lent by the artist, Kfar Bilu
PLATE 30

TAL MATZLIAH
Untitled 1995
Oil and paper on board
26 ¾ x 22 in. (68 x 56 cm)
Collection Robert Yohay, Tel Aviv

TAL MATZLIAH
Untitled 1996
Oil and paper on board
Diptych, each 19 ¼ x 32 ¾ in.
(48.9 x 83.3 cm)
Collection Jonathan Kolber and
Charles Bronfman, Tel Aviv

TAL MATZLIAH
Decoration for Shavuot 1998
Oil and paper on board
19 ¹¹⁄₁₆ x 27 ⁹⁄₁₆ in. (50 x 70 cm)
Lent by the artist, courtesy Noga
Gallery of Contemporary Art,
Tel Aviv
PLATE 34

ADI NES
Untitled 1996
Color photograph
35 ½ x 35 ½ in (90 x 90 cm)
Lent by the artist, Tel Aviv
PLATE 5

ADI NES
Untitled 1996
Color photograph
35 ½ x 35 ½ in. (90 x 90 cm)
Lent by the artist, Tel Aviv

LEA NIKEL
Book 1991
Silkscreen
Edition of 75; 17 ¾ x 29 ½ in.
(45 x 75 cm); 32 pages, 32 images
Lent by Har-El Printers and
Publishers, Jaffa

LEA NIKEL
Gesture for Rabin and for Peace 1995
Acrylic on canvas
65 x 65 in. (165 x 165 cm)
Lent by the artist, Moshav Kidron
PLATE 13

MOSHE NINIO
Orange: Kythira 1996
Video
7 minutes
Lent by the artist, Tel Aviv
PLATE 18

IBRAHIM NUBANI
Untitled 1994
Acrylic on canvas
47 ¼ x 47 ¼ in. (120 x 120 cm)
Lent by Chelouche Gallery, Tel Aviv
PLATE 35

IBRAHIM NUBANI
Untitled 1996
Oil on canvas
47 ¼ x 47 ¼ in. (120 x 120 cm)
Lent by Chelouche Gallery,
Tel Aviv

GILAD OPHIR
From the **Necropolis** series 1996
Gelatin silver print
49 ½ x 56 in. (125.7 x 142.2 cm)
Lent by the artist, courtesy Noga
Gallery of Contemporary Art,
Tel Aviv
PLATE 17

GILAD OPHIR
From the **Necropolis** series 1996
Gelatin silver print
49 ½ x 56 in. (125.7 x 142.2 cm)
Lent by the artist, courtesy Noga
Gallery of Contemporary Art,
Tel Aviv

DAVID REEB
**Orange-and-Blue TV Contact Sheet
(Sour Grapes)** 1996
Acrylic on canvas
63 x 55 ⅛ in. (160 x 140 cm)
Lent by Givon Art Gallery Ltd.,
Tel Aviv
PLATE 7

DAVID REEB
Let's Have Another War #3 1997
Acrylic on canvas
63 x 55 ⅛ in. (160 x 140 cm)
Collection Sam Givon, Tel Aviv

SIMCHA SHIRMAN
City's Border, Mody'in 1997
Group of 13 photographs
Each 11 ⅞ x 15 ¾ in. (30 x 40 cm);
overall 115 ⅜ x 46 ⁷⁄₁₆ in.
(293 x 118 cm)
Lent by the artist, Tel Aviv
PLATE 22

DORON SOLOMONS
My Collected Silences 1996
Video, 4 minutes
Lent by the artist, Ramat Gan
PLATE 6

IGAEL TUMARKIN
Book of Zacharia 1996
Etching, cut plates, and letter press
Edition of 35; 15 ¾ x 18 ¼ in.
(40 x 46 cm); 7 pages, 7 images
Lent by Har-El Printers and
Publishers, Jaffa

IGAEL TUMARKIN
You Shall Not Kill 1996
Mixed media on canvas
50 ⅜ x 37 ¹³⁄₁₆ in. (128 x 96 cm)
Lent by the artist, Jaffa
PLATE 8

URI TZAIG
Forest—Postcard Rack 1995
Postcards and postcard rack
Postcards: each 4 x 6 in.
(10.2 x 15.2 cm)
Rack: 67 x 23 ⅝ in. (170 x 60 cm)
Lent by the artist, Tel Aviv
PLATE 15

URI TZAIG
House 1995
Wood, box, and printed papers
39 ⅜ x 19 ¹¹⁄₁₆ x 19 ¹¹⁄₁₆ in.
(100 x 50 x 50 cm)
Lent by the artist, Tel Aviv

URI TZAIG
Play 1996
Table, glass, plywood, and video
projection
25 ⅝ x 25 ⅝ x ³⁄₁₆ in.
(65 x 65 x .5 cm)
Lent by the artist, Tel Aviv

MICHA ULLMAN
Day, Havdalah, and **Midnight**
from the **Containers** series 1993
Iron plates and sand
Day: 6 ⅞ x 9 ½ x 12 ½ in.
(17.5 x 24 x 32 cm)
Havdalah: 6 ⅞ x 12 ½ x 9 ⅞ in.
(17.5 x 32 x 25 cm)
Midnight: 9 ⅞ x 9 ½ x 12 ½ in.
(25 x 24 x 32 cm)
Collection The Israel Museum,
Jerusalem. Gift of Rita and Arturo
Schwarz, Milan
PLATE 23

PAVEL WOLBERG
Untitled 1997
Color photograph
27 ½ x 39 ⅜ in. (70 x 100 cm)
Lent by the artist,
courtesy Dvir Gallery, Tel Aviv
PLATE 25

PAVEL WOLBERG
Untitled 1997
Color photograph
27 ½ x 39 ⅜ in. (70 x 100 cm)
Lent by Dvir Gallery, Tel Aviv

PAVEL WOLBERG
Untitled 1997
Color photograph
27 ½ x 39 ⅜ in. (70 x 100 cm)
Lent by Dvir Gallery, Tel Aviv

Selected Bibliography of Contemporary Israeli Art

*The works listed are primarily in English;
the majority have been published since 1980.*

Exhibition Catalogues

Almog, Oz, and Felicitas Heimann-Jelinek. *Bamot*—the
building, destruction, and restoration of High Places* (*Israel
1948–1998*). Vienna: Vienna Jewish Museum, 1998.

Ayal, Avishay. *Four Realist Painters* [Mitch Becker, Shalom
Flash, Israel Hershberg, Hava Raucher]. Haifa: University
of Haifa, 1996.

Ballas, Gila. *The Group of Ten: 1951–1960*. Ramat Gan:
The Museum of Israeli Art, 1992.

Bar Or, Galia. "*Hebrew Work*": The Disregarded Gaze
in the Canon of Israeli Art. Ein Harod: Mishkan Le'Omanut,
Museum of Art, and The Israeli Forum of Art Museums,
1998.

Barron, Stephanie, and Maurice Tuchman. *Seven Artists
in Israel, 1948–1978*. Los Angeles: Los Angeles County
Museum of Art, 1979.

Baruch, Adam. *The Israeli Photography Biennale*. Jerusalem:
The Domino Press, 1998.

Berman, Reuven. *The Rational Factor in Works by Israeli
Artists*. Haifa: Haifa Museum of Modern Art, 1984.

Bolas, Gerald D., Gideon Ofrat, and Michael Sgan-Cohen.
Ketav: Flesh and Word in Israeli Art. Chapel Hill, N.C.:
Ackland Art Museum, 1996.

Boneh, Miriam Tovia. *Anxiety*, Art Focus. Ramat Gan:
The Museum of Israeli Art, 1994.

Breitberg-Semel, Sara. *Artist and Society in Israeli Art,
1948–1978*. Tel Aviv: Tel Aviv Museum of Art, 1978.

———. *The Want of Matter: A Quality in Israeli Art*.
Tel Aviv: Tel Aviv Museum of Art, 1986.

———. *Positionen Israel*. Berlin: Künstlerhaus
Bethanien, 1992.

Cassouto, Nella. *Long Memory/Short Memory*. Raleigh, N.C.: The City Gallery of Contemporary Art, 1996.

Donner, Batia. *To Live with a Dream*. Tel Aviv: Tel Aviv Museum of Art and Dvir Publishers, 1989.

Ginton, Ellen. *Feminine Presence: Israeli Women Artists in the Seventies and Eighties*. Tel Aviv: Tel Aviv Museum of Art, 1990.

————. *Virtual Reality*. Tel Aviv: Tel Aviv Museum of Art, 1996.

————. *Perspectives on Israeli Art of the Seventies: The Eyes of the Nation—Visual Art in a Country Without Boundaries*. Tel Aviv: Tel Aviv Museum of Art, 1998.

Goodman, Susan Tumarkin. *Artists of Israel: 1920–1980*. New York: The Jewish Museum, 1981.

————. *In the Shadow of Conflict: Israeli Art 1980–1989*. New York: The Jewish Museum, 1989.

Hakkert, Sara. *Imagewriting: The Verbal Component in Israeli Art Toward the '90s*. Ein Hod, Israel: Janco-Dada Museum, 1992.

Harten, Doreet LeVitté. *Israeli Art Around 1990*. Cologne: DuMont Buch Verlag; Düsseldorf: Städtische Kunsthalle, 1991, and Jerusalem: The Israel Museum.

Katz-Freiman, Tami. *Antipathos: Black Humor, Irony, and Cynicism in Contemporary Israeli Art*. Jerusalem: The Israel Museum, 1993.

————. *Meta-Sex '94: Identity, Body, and Sexuality*. Ein Harod, Israel: Mishkan Le'Omanut, 1994.

————. *Postscripts*. Tel Aviv: Tel Aviv University, 1992.

Katz-Freiman, Tami, and Amy Cappellazzo. *Desert Cliché: Israel Now—Local Images*. Tel Aviv and Miami Beach: The Israeli Forum of Art Museums and the Bass Museum of Art, 1996.

Manor, Dalia. *New Bezalel: 1935–1955*. Jerusalem: Bezalel Academy of Art and Design, 1987.

————. *Origins of Eretz-Israeli Sculpture, 1906–1939*. Herzliya: The Herzliya Art Museum, 1990.

————. *Perspective: New Aesthetic Concepts in Art of the Eighties in Israel*. Tel Aviv: Tel Aviv Museum of Art, 1991.

————. *The Sacrifice of Isaac in Israeli Art*. Ramat Gan: The Museum of Israeli Art, 1987.

————. *1948: The War of Independence in Israeli Art*. Tel Aviv: Eretz Israel Museum, 1988.

Omer, Mordechai. *The Column in Contemporary Israeli Sculpture*. Tel Aviv: Tel Aviv University, 1990.

————. *The Presence of the Absent: The Empty Chair in Israeli Art*. Tel Aviv: Tel Aviv University, 1991.

————. *Tikkun: Perspectives on Israeli Art of the Seventies*. Tel Aviv: Genia Schreiber Art Gallery, Tel Aviv University, 1998.

————. *Upon One of the Mountains*. Tel Aviv: Tel Aviv University, 1988.

Rachum, Stephanie. *Borders*. Jerusalem: The Israel Museum, 1980.

Roberts, Linda Foard, and Alice Sebrell. *A Delicate Balance: 6 Israeli Photographers*. Charlotte, N.C.: The Light Factory, 1996.

Scheps, Marc, Meira Yagid, and Ellen Ginton. *The Twenties in Israeli Art*. Tel Aviv: Tel Aviv Museum of Art, 1982.

Schroth, Mary Angela. *Halal—arte contemporanea da Israele*. Rome: Fratelli Palombi, 1994.

Sela, Rona. *90>70>90*. Tel Aviv: Tel Aviv Museum of Art, 1994.

Shakked, Shlomit. *Locus: Contemporary Art from Israel.* Los Angeles: University of Southern California, 1993.

Shapira, Sarit. *Routes of Wandering: Nomadism, Voyages and Transitions in Contemporary Israeli Art.* Jerusalem: The Israel Museum, 1991.

————. *Black Holes: The White Locus.* Tel Aviv: The Israeli Society for Culture and the Arts, 1994.

Shilo-Cohen, Nurit, ed. *Bezalel: 1906–1929.* Jerusalem: The Israel Museum, 1983.

Steinitz, Ami. *The 21st International Biennale of São Paulo 1991: Israel.* Tel Aviv: Ministry of Education and Culture, 1991.

Tammuz, Benjamin, Dorit LeVitté, and Gideon Ofrat, eds. *The Story of Art in Israel.* Tel Aviv: Massada, 1980.

Talmor, Daniella. *Friends (Art Focus).* Haifa: Museum of Modern Art, 1994.

————. *Peacemakers.* Haifa: Museum of Modern Art, 1995.

Tolkovsky, Zvi. *Mutual Feedback.* Jerusalem: Jerusalem Print Workshop, Florence Miller Art Center, 1993.

Venice Biennale, Israeli Pavilion (exhibition catalogue). Jerusalem: Israeli Society for Culture and Art, 1995.

Yaffe, A.B., ed. *The First Twenty Years—Literature and Art in Tel Aviv 1909–1929.* Tel Aviv: Hakibbutz Ha'meuchad, 1990.

Zalmona, Yigal. *Here and Now: Israeli Art, Painting and Sculpture, Drawing, Photography, Video.* Jerusalem: The Israel Museum, 1982.

————. *To the East: Orientalism in the Arts in Israel.* Jerusalem: The Israel Museum, 1998.

Books

Barzel, Amnon. *Art in Israel.* Milan: Giancarlo Politi Editore, 1987.

Fuhrer, Ronald. *Israeli Painting.* Woodstock, N.Y., and London: The Overlook Press in association with Ronald Lauder, 1998.

Luski, Haim, ed. *City and Utopia: 80 Years to Tel Aviv-Jaffa.* Tel Aviv: Israel Art Publishers, 1990.

Melamed, Joseph A. *Art in Israel Today.* New York: World of Art, 1991.

Ofrat, Gideon. *Gardens in the Air.* Tel Aviv: Israel Art Publishers, 1991.

————. *100 Years of Art in Israel.* Boulder, Colo.: Westview Press, 1998.

————. *Nimrod with Tefillin.* Tel Aviv: Israel Art Publishers, 1996.

————. *On the Ground.* Vols. 1 & 2. Tel Aviv: Israel Art Publishers, 1993.

————. *Touch: Israeli Art at the End of the Eighties.* Jerusalem: Israel Art Publishers, 1988.

Shechori, Ran. *Art in Israel.* Tel Aviv: Sadan Publishing House, 1974.

Shva, Shlomo. *To Paint the Homeland.* Tel Aviv: The Ministry of Defense, 1992.

Zalmona, Yigal. *Landscapes in Israel Art.* Jerusalem: D. K. Graubart Publishers, 1984.

The Jewish Museum
Board of Trustees

Photo Credits